altered Curiosities

ASSEMBLAGE TECHNIQUES AND PROJECTS

Jane Ann Wynn

NORTH LIGHT BOOKS

Cincinnati, Ohio

11 10 09 08 07 5 4 3 2 1

Distributed in Canada by Fraser Direct
100 Armstrong Avenue
Georgetown, ON, Canada L7G 5S4
Tel: (905) 877-4411

Distributed in the U.K. and Europe by David & Charles
Brunel House, Newton Abbot, Devon, TQ12 4PU, England
Tel: (+44) 1626 323200, Fax: (+44) 1626 323319
Email: postmaster@davidandcharles.co.uk

Distributed in Australia by Capricorn Link
P.O. Box 704, S. Windsor, NSW 2756 Australia
Tel: (02) 4577-3555

Library of Congress Cataloging-in-Publication Data

Wynn, Jane Ann.
 Altered curiosities : assemblage techniques and projects / Jane Wynn.
 p. cm.
 Includes index.
 ISBN-13: 978-1-58180-972-5 (pbk. : alk. paper)
 1. Assemblage (Art) 2. Collage. I. Title.
 TT910.W96 2007
 702.81'2--dc22
 2007005125

Editor: Tonia Davenport
Designers: Marissa Bowers and Cheryl Mathauer
Production Coordinator: Greg Nock
Photographers: Christine Polomsky and Al Parrish
Photo Stylist: Jan Nickum

❖ Dedication ❖

To my very dear sweet boy—my loving husband, who clears the cluttered path so that I may run freely on my journey.

To my wonderful parents, who thought that being an artist was just as brilliant as becoming an accountant or a scientist, and gave me crayons, paint and a lot of love.

I am humbled by my accomplishments.
I am truly grateful for my opportunities.
I am very lucky for the fortunes in my life.
I love what I do.
I love the people around me who encourage and support me.

To Paige—you are always in my thoughts.

❖ Acknowledgments ❖

I would like to thank North Light Books for taking the chance to represent me and my work in this wonderful way. I would also like to thank my editor, Tonia Davenport, for seeking me out, believing in me, and for becoming a very dear friend during this creative process. You are a brilliant woman who stands as strong as a fir tree in the blustery wind. To my photographer, Christine Polomsky, I thank you for your bright optimism and for all of your hard work; you are simply charming and a joy to be around. To Marissa Bowers and Cheryl Mathauer for the icing on my book "cake," for making things look so wonderfully curious! Finally, to the rest of the North Light family of worker bees, I thank you for all of your hard work and dedication to this project; I am humbled by this opportunity.

One last note: To my students—past, present and future—this book is your guide and inspiration for finding your authentic artistic voice. I share my ideas, my thoughts and my visions in hopes that you will be inspired as you walk along your path to becoming the artist you are meant to be. I wish you many hours of enjoyment and curious discovery.

Contents

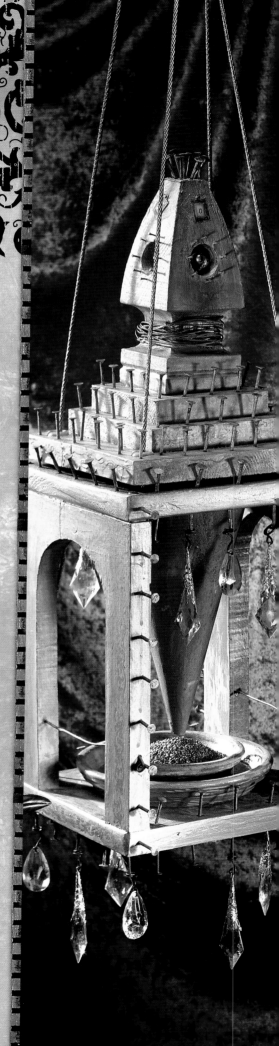

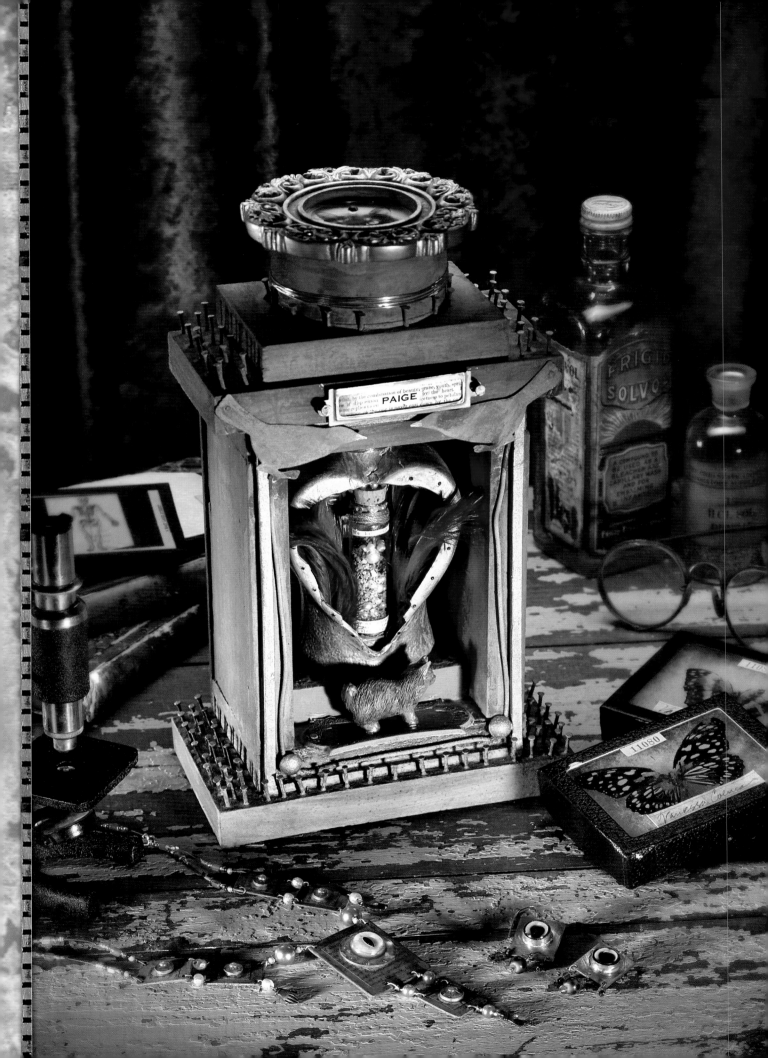

the beautiful—the odd—the curious

When I was young, I was foolishly led to believe that artists made art. A painter painted, a sculptor sculpted, an illustrator drew pictures and everything fit nicely into neat and pretty categories. Little did I know that my world would come crashing down around me when I let my curiosity get the better of me.

I did my time in art classes and followed the rules. I stretched canvases, squeezed many tubes of paint onto my palette and mixed every color of paint under the sun. I sank my fingers into cool wet clay and carved deep gouges into wood. I drew and sketched, and kept many sketchbooks that held my deepest thoughts and ideas. I learned great things from my art education and yet, in the end I was still left asking myself, "Is this it?" I was restless. I wanted to make art in the moment. I wanted to cross boundaries and mix media so I could capture my many messages in the work I was making. I changed my thinking, and my work began to grow. I found freedom in breaking boundaries and being curious! Ten years later I am here making art by my own rules. I am a painter who draws and a sculptor who paints. I illustrate with my hands. I challenge myself by my own definitions, and leave behind a world of limitations.

It is not without struggle, of course. All of us, at one time or another, have had feelings of frustration and discontent in the art-making process. Sometimes it is as simple as learning a new technique or just a matter of refining some of the skills we already have. Other times, it is the search for a meaning or a message to breathe life into the work.

I invite you to join me as I journey into the altered-art, mixed-media, assemblage-making process. It is one filled with many of my personal stories and experiences, as well as some great techniques, unusual ideas and innovative directions. If you are curious by nature and have an adventurous spirit, I am sure you will delight in all the odd and unusual things I have to share. After all, curiosity can't kill a cat with nine lives.

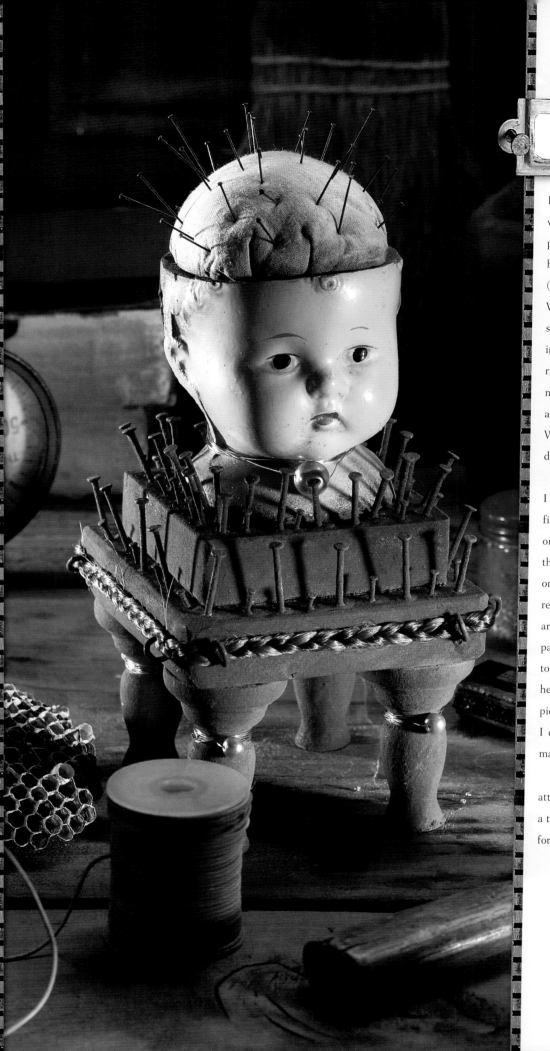

A Very Olde Tyme Pin Cushion

During the 1930s when my mother was a child, among her most treasured possessions were a top, a few alphabet blocks, a stuffed pig with overalls (named Piggy) and her lovely dolls. When I was a child, I would hear the stories of teatime, backyard exploring and dress up, as if I were playing right there alongside of them with my mother. She loved her dolls very much and they were as real to her as anyone. We call them vintage and antique these days, but to her, they were her friends.

Throughout the last several years, I have been collecting old dolls. They find me at flea markets in spring, or on online auctions in the middle of the night. My favorites are the ones no one wants—the ones deemed "beyond repair." I feel sad for these toys. They are so worn and played with, have lost parts and are no longer of any real value to anyone. Sometimes all that is left is a head. I wonder where the rest of these pieces end up. Sometimes if I am lucky, I can replace an arm that was lost or match up a pair of legs.

The pin cushion you see here is my attempt to give new life and purpose to a toy that was once loved in a different form, but can still be loved today.

Techniques

When I was a child, I remember the thrill I felt in my heart from playing with my toys. There was never a more exciting time for me than the approaching holiday season. I would look forward to spending time in the evenings, sitting on the soft big chair in the living room, and poring over the Sears catalog while my parents watched television. I would start at the beginning of the catalog and slowly and methodically look at every item, as if I had such difficult decisions to make. I would give this charming activity all of my time and attention and stretch it out for hours and sometimes days.

Toys were a real treat for me. I would take them outside with me to play during the long, hot, summer days and play right through into bitter-cold January afternoons. The sun would eventually fade their colors, and they would become nicked and worn from all of my childhood wear and tear, but it was a true testament to my love.

I think these memories from my childhood are my inspiration for altering and aging new toys in my work. Now that I am older, when I decide to use a "new" and "modern" toy for a piece of art with its perfect coat of paint and all of the parts in fine working order, I cannot feel an attachment to it. It is far too new and soulless. It is my desire to recall lovely memories from my early days by changing this new toy: aging the surfaces, rearranging parts, and finding a feeling of freedom from days gone by.

I rely a lot on imagination, when it comes to the strange work I create. At times, even I think my art is a little bizarre and askew from the everyday world around me. I love to challenge myself and my thoughts by pushing things into a pseudo-distorted fairy-tale world. At times I may allow myself to create something like a conjoined pet, which to some may seem dark and melancholy and to others it is just odd and somewhat charming and delightful. I love that balance, no matter how difficult a fine line it is to walk.

Becoming an archeologist was way up there on my list of occupations, as well as oceanographer, a monster maker for movies and a jockey. At the age of nine I could sit for hours in my backyard and dig holes, thinking that I was going to discover some secret trinket from the past. Occasionally I would find great things, like broken glass, bits of rusted metal and some of my brothers' small toy cars that they had lost a year or two before. I think my parents were happy that I did not need too many toys to keep me entertained, but my father was not too pleased to find a small land mine every time he went to mow the grass.

I am still drawn to exploring and digging for ancient buried treasures. For several years now, I have been reading science articles about buried treasures. Whether found at sea or unearthed from the dry desert sands of some far-off country, I adore the effects of time and weather on objects, which were once so new. I have a particular attraction to Roman glass, fossils and tattered, threadbare cloth. I hope you think of the techniques on the following pages as a porthole to your own natural history museum where you can alter, age and transform objects of your very own into something curious. Welcome to my pseudo-distorted, fairy-tale world . . .

Altering
Toys

Altering toys is a lot like playing doctor without the ethics or rules! I get a thrill from bending the rules of nature by removing a head or a hoof from one toy body and replacing it with another to make something more unique! With the help of a craft knife, some modeling putty, a kooky imagination and some simple instructions, you too can make a one-of-a-kind altered toy.

Secret Ingredients

plastic toy figures

two-part putty (Kneadatite)

craft knife

needle tool

dressmaker pins

needle-nose pliers

acrylic or enamel paints

detail brushes

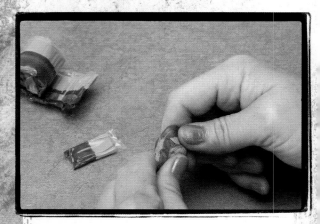

{1} Mix up putty
Cut off a small section of the two-part putty and begin kneading it together. When it's mixed, set the compound aside.

{2} Dissect desired area
Using a craft knife, remove the portion of the toy (here, the head) that you wish to alter.

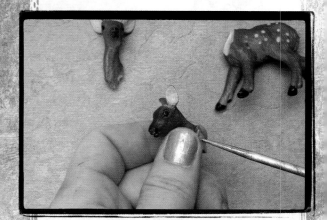

{3} Make starter holes
Using a needle tool, make some starter holes in the toy pieces for the pins that will later hold the toy pieces together.

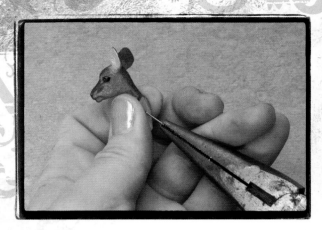

{4} Snip pin heads

Remove the heads from a couple dressmaker pins with a nipper or your needle-nose pliers.

{5} Insert pins

Insert one pin piece into one of the toy pieces that will be attached. Use pliers if necessary.

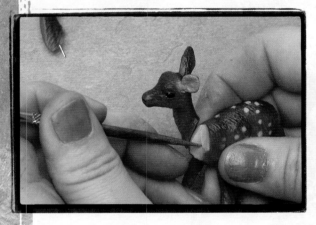

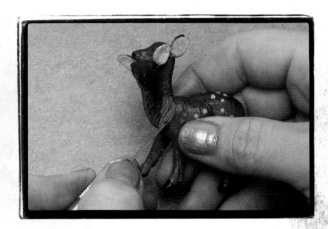

{6} Attach pieces

Attach the pieces to the toy base, making additional stater holes for second or third pieces as necessary.

{7} Add putty

Using the putty that was kneaded in step one, begin filling in the gaps made at the sites of the attachments. A craft knife or needle tool is helpful for working the putty into the cracks. Smooth putty over the surface to make the connections appear seamless. If needed, add texture to the putty (such as the indentation lines that suggest fur) using a needle tool. Let the toy cure for about an hour.

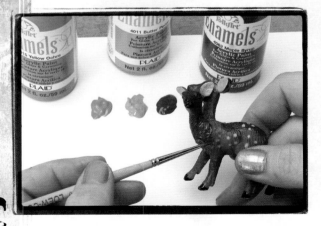

{8} Paint the toy

You can spray paint the entire piece and then add a patina (see Applying a Patina, page 30), or touch up the areas of putty with acrylic or enamel paint.

Altering an Egg

One day, I reached for a lovely, autumn-colored egg when I was preparing breakfast. It was the most richly colored egg I had ever seen—covered in dark spots and surprisingly heavy. I could not crush this egg. After ten minutes of scratching and tracing, I pierced through to the liquid center. The little window opened and out came the insides! I cleaned it up carefully and transfomed it into a tiny reliquary. This began my passion for delicate organic shrines.

Secret Ingredients

raw egg in shell	acrylic paint
pencil	brush
craft knife	small spool
small bowl	collage text
two-part epoxy	bee or other small charm
craft stick	
file or sandpaper	

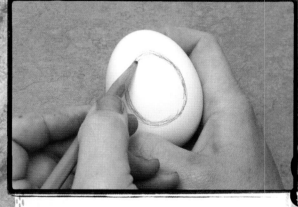

{1} Sketch an opening

Sketch an opening on one side a whole egg, fresh out of the carton, using a pencil.

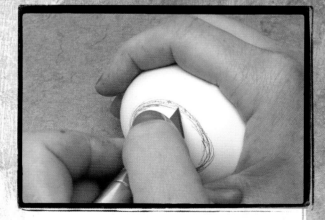

{2} Score a line

Use a craft knife to scratch out a score line around the pencil mark. Be patient and work your way slowly around the line.

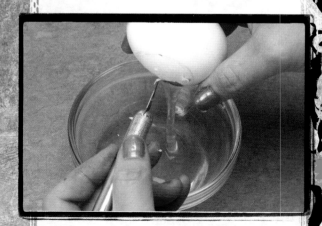

{3} Pop out the opening

Continue scratching around the line until a hole begins. Pop out the opening with the craft knife. The shell will break away along the scored line.

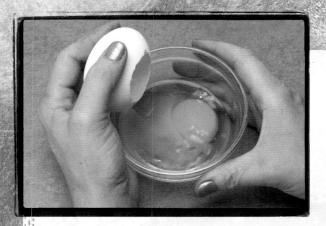

{4} Empty out contents

Empty the bulk of the egg's contents into a bowl. Give the shell a quick wash with water to clear out the inside and let dry.

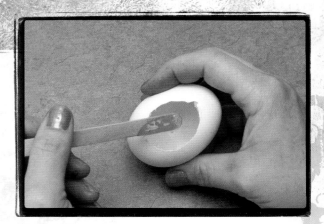

{5} Add epoxy

Mix up a two-part epoxy and use a craft stick to spread it around the inside of the egg shell, and along the opening's edge.

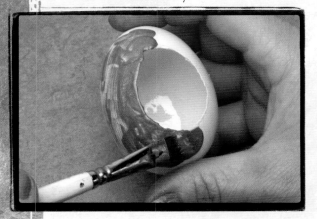

{6} Paint egg (optional)

Use a file or a piece of sandpaper to smooth jagged areas of the opening or remove any fingerprints. The egg is now ready to use as a shrine as is, or you can paint it first. Here I decided to paint it with gold metallic paint and then add a patina to it later.

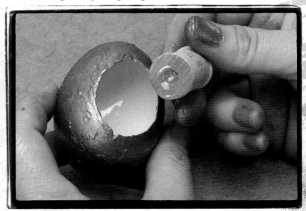

{7} Add spacer

When you want to mount an object inside the egg, but you want it to be more visible than it would be if it were at the back, you can bring it forward by attaching it to a small block or spool that you glue into the egg first.

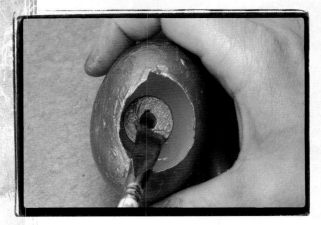

{8} Disguise spacer

Depending on whether some of the spool might show, you may want to paint the top of the spacer as well. Let dry.

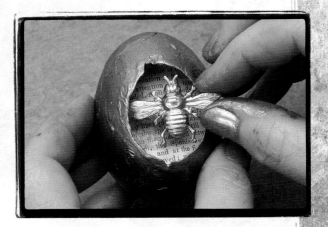

{9} Mount object

Mount your desired object onto the spool. Here I first mounted a piece of collage text, then attached a bee charm.

Controlled Breaking of Glass

When I first decided to use glass vessels and bottles in my work, I knew I would have to figure out some way to alter them so they wouldn't appear shiny and new. The first thought that came to mind was to age the surface to mimic a lovely museum artifact. I had to carefully and deliberately break a piece for it to appear ancient. By breaking them and piecing them back together, I add my own personal history and it becomes shrouded in mystery.

Secret Ingredients

glass bottle

sandpaper (coarse)

masking tape

glass cutter

towel or bandana

hammer

two-part epoxy

craft stick

metallic paint (iron)

brush

patina (green)

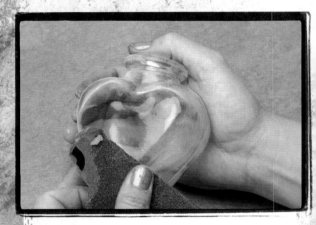

{1} Sand glass

Use a piece of sandpaper to scratch the surface of the glass. You don't have to sand the entire piece, but the patina will not "stick" to any place that isn't roughed up.

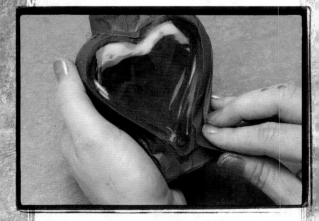

{2} Cover glass with tape

Apply masking tape to the bottle except where you want the opening to be (in this case, at the front of the bottle).

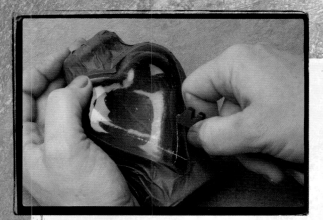

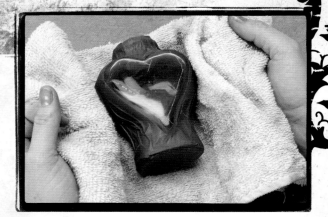

{3} Score a line

Use a glass cutter to score a line for the opening. This does not have to be perfect as long as you stay close to the intended opening. The tape will help guide you.

{4} Wrap bottle

Wrap the bottle up in a towel.

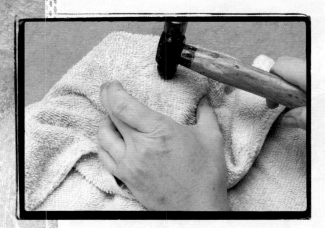

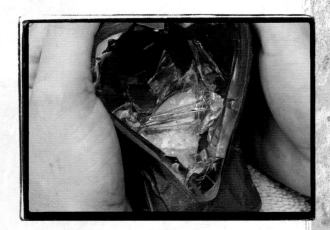

{5} Pop out opening

Gently but firmly, use a hammer to tap the bottle where the opening is. You should hear a "pop" and feel the glass give way under the hammer.

{6} Discard broken bits

Unwrap the towel and verify that the glass broke where you wanted. Dump out the broken pieces.

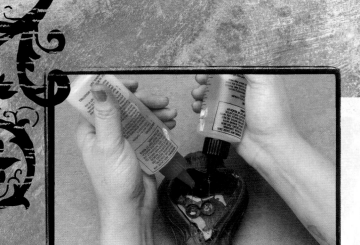

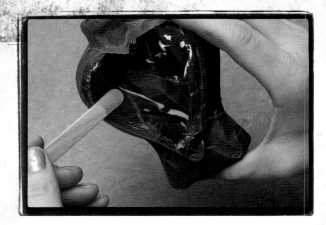

{7} Add epoxy

Squeeze about two tablespoons (30mL) of the two-part epoxy, into the bottle. Be sure to keep the proportions equal.

{8} Spread epoxy

Using a craft stick, spread the epoxy around the inside of the bottle.

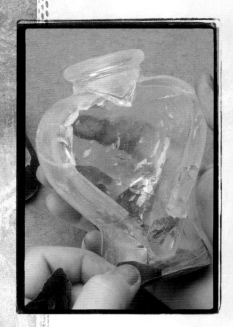

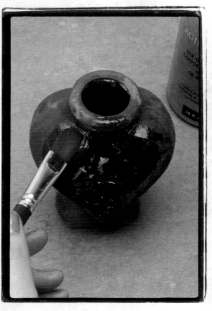

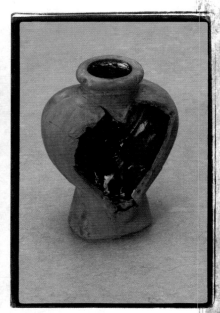

{9} Remove tape

When the epoxy has dried, remove the tape. You can now leave the jar as is, or you can take it a step further and add metal paint to prepare it for a patina.

{10} Add a patina

First brush on a coat of metal paint (I chose iron) and let it dry. Apply green patina solution to give the iron a nice rust.

{11} Let patina dry

Your bottle is now ready to fill with whatever you like!

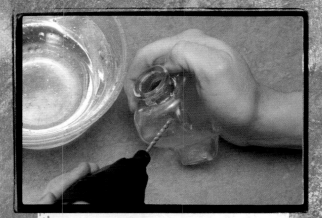

{1} Start with wet bit

Dip the bit into the water and apply very gentle pressure to the spot where you want a hole, using a slow speed on the Dremel or drill. Every few moments, dip the bit back into the water. If the drilling gets dry, the glass may crack.

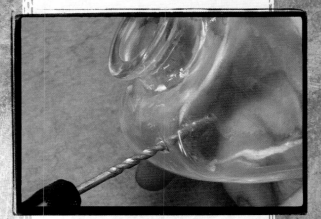

{2} Continue drilling slowly

Continue drilling slowly (about two minutes) until the bit goes all the way through the glass.

Forming Metal into a Cup

You don't have to be a sideshow strongman to bend a piece of metal into fancy forms. I have found quick and easy ways to coerce metal into different shapes without having to lift weights every day!

Two tools are used to form a metal dome: a dapping block and a dapping punch. The steel block has six sides. Each side has different-sized depressions, allowing you to create a range of different depths and sizes. Along with a dapping block, you will need to use a dapping punch. These punches are made of steel and range in size. The dapping punch can be used on its own by setting it in a vise and hammering the metal over the top of the steel head. It will not give you as smooth of a surface as the block, since you are hammering onto metal directly, but you will be able to form a piece of metal into a sphere. When used together, the dapping block and the dapping punch help form a lovely metal dome without blemishing its smooth surface.

Secret Ingredients

20-gauge or harder sheet metal or metal discs (Metaliffers)

circular shape or template

permanent marker

jeweler's saw

dapping tools

hammer

soldering screen, stand and torch (optional, but recommended)

sandpaper, fine grade

Who Knew?

If you are looking for a common size for a shape, you can always purchase precut forms from a variety of companies.

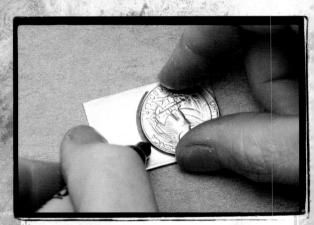

{1} Draw circle
If not starting with a disc shape, use a quarter as a template to cut a circle from a sheet of metal.

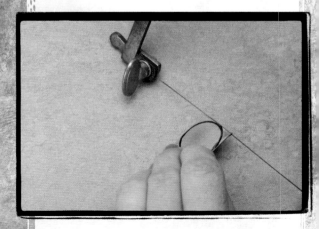

{2} Cut circle out
Cut the shape out with a jeweler's saw.

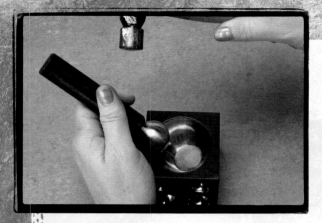

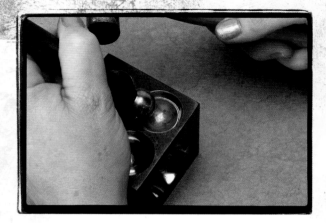

{3} Set disc in block

Set the circle into the largest circle of the dapping block, and use a hammer to begin pounding it into a curved shape.

{4} Graduate sphere size

Proceed to a smaller sphere shape and continue to pound it into shape. Continue with smaller and smaller spheres until the sides have curved up to the desired height.

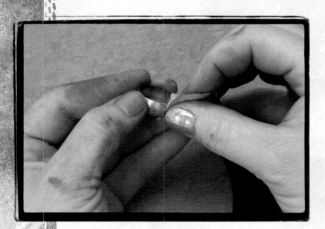

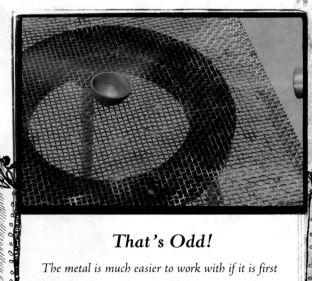

{5} Polish cup

Using fine-grade sandpaper, polish the cup to restore the metal's original color.

That's Odd!

The metal is much easier to work with if it is first heated with a torch on a soldering screen and stand (see Soldering, page 24). This technique is called annealing. The metal will remain warm and soft enough to easily work with for a while. As you work, if it cools down to the point of being difficult to manipulate, just heat it up again!

Binding Metal with Epoxy

When I began working in metal at my university, I had a full jewelry studio at my disposal—fire and solder a plenty. However, when I was home in my small spare bedroom studio, I did not have these tools on hand. I began to research different ways of connecting metal without the use of heat.

Binding metal without the luxury of heat and solder is known as making a cold connection. I first bound pieces together with wire using different wrapping techniques. I then experimented with rivets and screws. These methods worked very nicely, but I was looking for a way to bind the metal without showing my connection. This meant using an epoxy or glue. One obstacle to gluing metal is its nonporous surface. I discovered that adding a binder between the two pieces helped tremendously in creating a sturdy bond. Any porous fiber will work as a binder—from muslin to paper towels. A two-part epoxy sets up fast and strong in under five minutes.

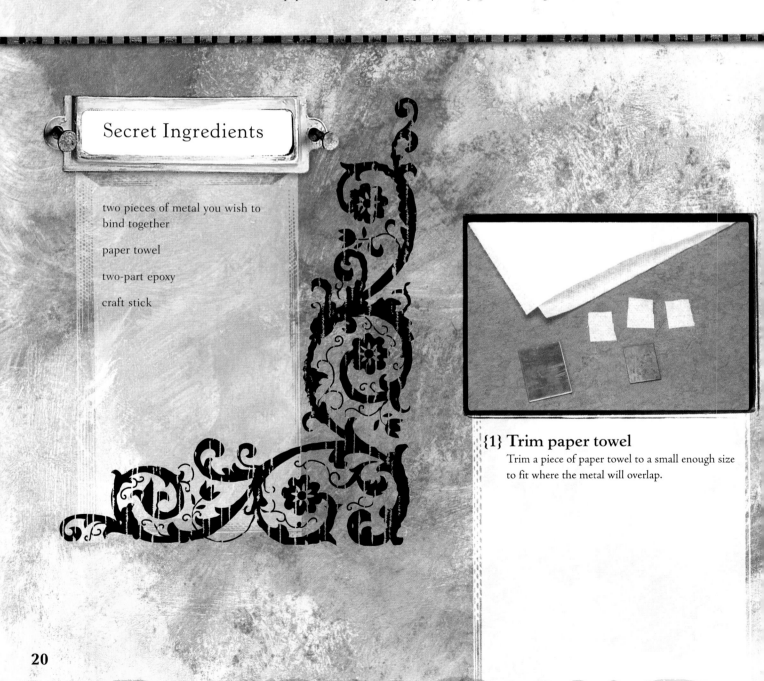

Secret Ingredients

two pieces of metal you wish to bind together

paper towel

two-part epoxy

craft stick

{1} Trim paper towel

Trim a piece of paper towel to a small enough size to fit where the metal will overlap.

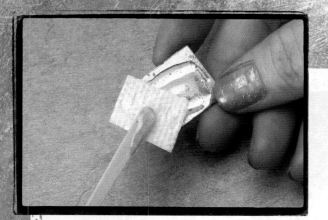

{2} Add epoxy

Use a craft stick to mix the two-part epoxy and apply a dot to one piece of metal. Set the piece of paper towel onto the epoxy.

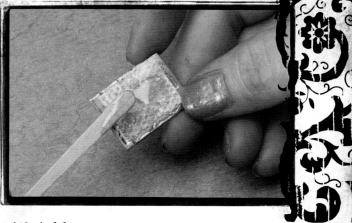

{3} Add more epoxy

Place another dab of epoxy over the paper towel.

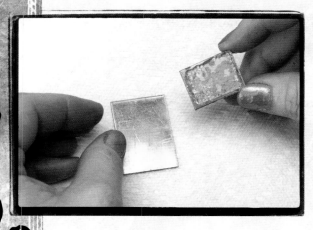

{4} Press metal together

Adhere the two pieces of metal together.

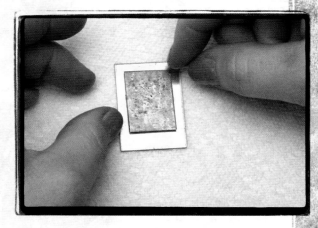

{5} Watch for slippage

Babysit the piece for five minutes to watch for slippage. Remove any excess epoxy (seepage) with a craft knife.

Creating a
Circular Bezel

I like to use pipe to make my own bezels. I get most of my pipe from hobby stores. It comes in brass, aluminum, steel and copper. I also discovered that using a tool called a pipe cutter is such a time-saver. It makes the task of cutting a round surface much easier than cutting it by hand.

Secret Ingredients

hobby pipe

round bezels

pipe cutter

base metal

metal file (optional)

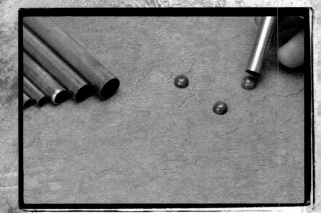

{1} Select a pipe

Select the bezel (stone) or object you want to set, and select a piece of pipe that is the correct diameter for the stone. A tiny bit of wiggle room is fine, but ideally, the pipe will be snug enough to hold the stone in on its own.

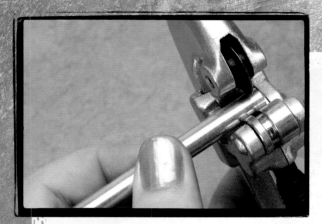

{2} Cut the pipe

Set the pipe in the pipe cutter and position the cutting wheel to cut the pipe to a width that is just slightly smaller than the height of the stone. (I usually just eyeball it.) Tighten the screw on the cutter to cut the pipe.

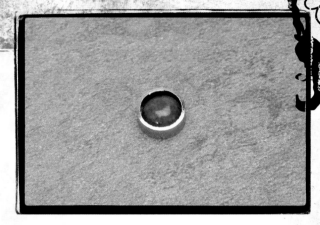

{3} Check size with stone

Set the pipe over the stone to check that you have cut it to the correct depth.

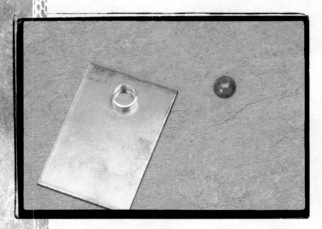

{4} Select a base

Select a base to set the bezel on, and you are ready to solder! (See Soldering, on the next page.)

Who Knew?

If one side of the cut piece has slight burrs on it, you can smooth them with a file.

Soldering

I have found soldering metal is easiest if you think of yourself as a plumber! I was watching a home improvement program on television one afternoon and I noticed how fast and easy it was for a homeowner to attach two pipes together using a simple propane torch and solder.

Try starting with a simple BernzOmatic Propane Torch Kit from your local home and garden store. It comes with a small propane tank and torch nozzle and is very affordable. I also like to use a metal soldering screen and a soldering tripod (purchased from an online jewelry supply store). These two items allow you to solder both the top and the bottom of a piece, while equally heating both sides. I like to use Stay-Brite solder and flux. (I think liquid flux makes a difference!)

Liquid flux allows hot solder to flow nicely along a joint. In some cases, you may need to reheat the surface again, or add a little more flux to help it continue to flow. If your piece has too much solder or messy seams, you can always go back and file and sand them smooth. Personally, I love the look of organic seams. I do not like to make things appear machine manufactured. I have a passion for imperfection!

Secret Ingredients

soldering screen

soldering tripod stand

propane torch (camping grade is fine)

lighter

silver solder

liquid flux

needle-nose pliers

bowl of water

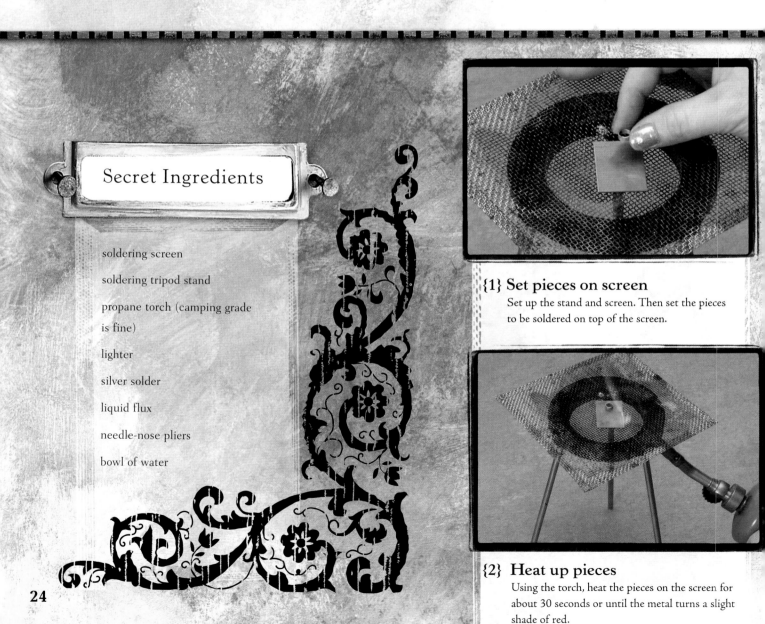

{1} Set pieces on screen
Set up the stand and screen. Then set the pieces to be soldered on top of the screen.

{2} Heat up pieces
Using the torch, heat the pieces on the screen for about 30 seconds or until the metal turns a slight shade of red.

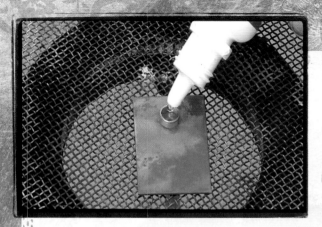

{3} Add flux

Add a drop of flux into the bezel.

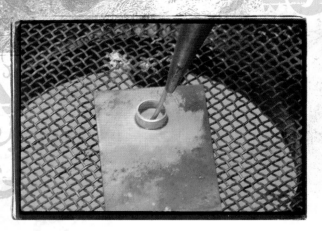

{4} Add solder

Set a tiny bit of solder to the flux and heat it to melt it into a puddle.

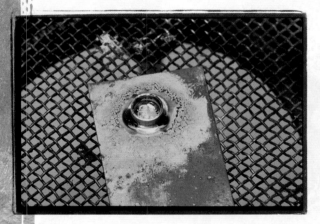

{5} Secure bezel

If the bezel moves, use pliers to gently tap it back into position while it's still hot.

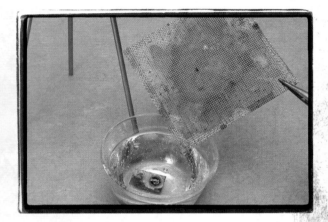

{6} Emerge piece in water

Grasp the screen with needle-nose pliers, and gently dump the hot soldered piece into a bowl of cool water.

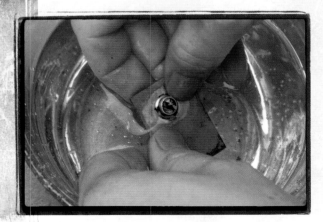

{7} Wipe off flux

While the piece is in the water, gently wipe off the flux to clean the piece.

Who Knew?

Do not add your stone until the piece has cooled. Never apply any heat to a stone as you might crack it.

Creating a Rectangular Bezel

At first sight, creating a rectangular bezel may seem like a difficult task; however, in actuality, it isn't. The key ingredient is flat bezel wire. You can find this online at a variety of jewelry supply sites. You can also use very light gauge (24-gauge up to 26-gauge) brass or copper strips of hobby metal. If you happen to be lucky enough to own a rolling mill, you can flatten and create your own strips from round wire.

Secret Ingredients

flat jewelry wire

base (a square piece of metal), at least 18 gauge or smaller

scissors or wire cutters

soldering supplies (see page 24)

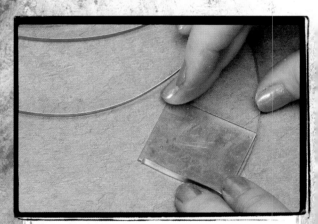

{1} Measure wire
Measure how much flat wire you will need by wrapping the wire around the base.

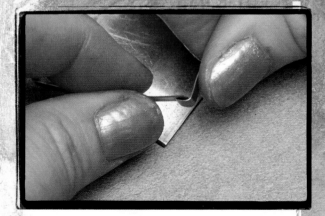

{2} Finalize form
Form the wire to the desired shape, and trim off any excess wire using scissors or wire cutters. Pinch the form enough so there is a little overlap where the ends meet.

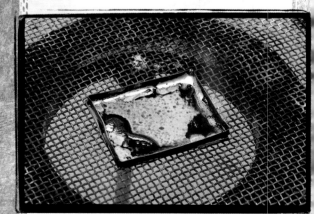

{3} Solder
The piece can now be soldered. (See Soldering, page 24.)

Creating an Irregular-Shaped Bezel

The process of making an irregular-shaped bezel is very similar to a rectangle except you use an object of your choice as a guide. Start with a flat base of metal. Place the irregular-shaped object on top of the metal. Hold it in place with your fingers; use your other hand to trace a piece of bezel wire around the outside of the object. If the object is very detailed, simplify the design by creating a more general outline.

Secret Ingredients

flat jewelry wire

base (a square piece of metal), at least 18 gauge or smaller

soldering supplies (see page 24)

scissors or wire cutters

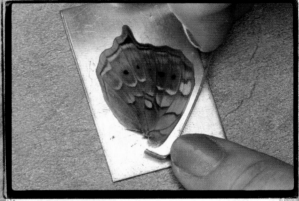

{1} Set object on base
Set the irregular object on a standard rectangular base. Measure the wire by wrapping it around the object, shaping it as you go.

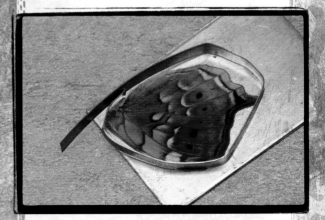

{2} Form and solder
Form the wire to the final desired shape and solder as you did on page 25.

Filling a Bezel with Resin

I love using resin to set an object in a bezel because it reminds me of those insects immortalized in hardened sap—a time capsule with a sense of suspended reality. I like to use Envirotex Lite resin. If my bezel will contain paper, newsprint or an image, I first seal the backside with simple white glue to prevent the paper from becoming transparent. For something delicate, such as a butterfly's wing, I very gently brush on a mixture of white glue and water (about the consistency of skim milk). Some plastic objects need to be sealed with a clear acrylic sealer before setting in resin; otherwise due to a chemical reaction between resin and plastic, the object may dissolve.

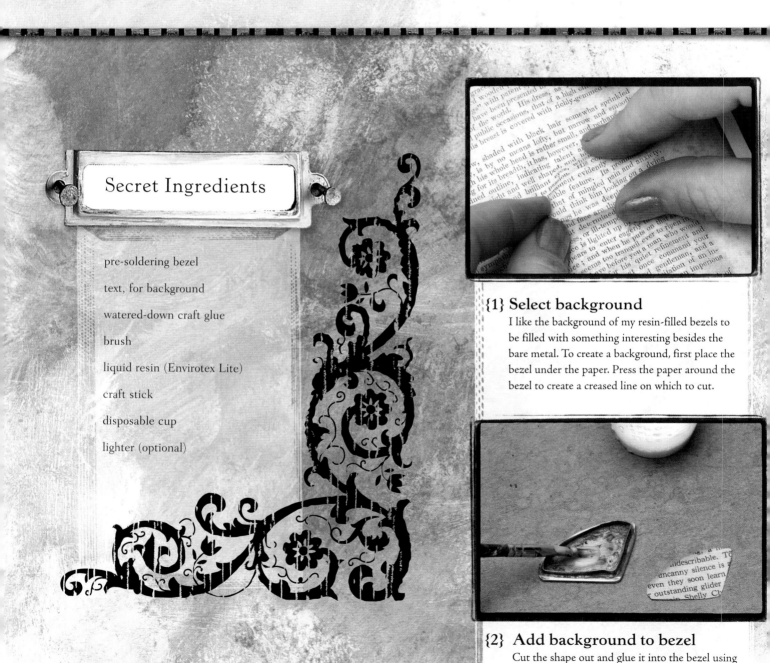

Secret Ingredients

pre-soldering bezel

text, for background

watered-down craft glue

brush

liquid resin (Envirotex Lite)

craft stick

disposable cup

lighter (optional)

{1} Select background

I like the background of my resin-filled bezels to be filled with something interesting besides the bare metal. To create a background, first place the bezel under the paper. Press the paper around the bezel to create a creased line on which to cut.

{2} Add background to bezel

Cut the shape out and glue it into the bezel using watered-down craft glue.

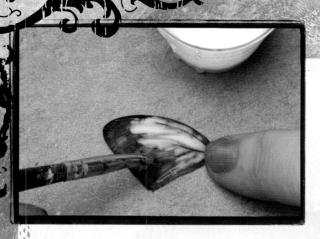

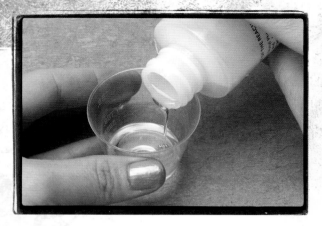

{3} Add object

When adding something delicate, brush the back of it with watered-down glue, and cover it completely before placing it on the background. Otherwise, just use a normal amount and consistency of glue to secure your object.

{4} Mix resin

Begin mixing the two-part resin into a disposable cup. Mix only as much as you will need, as you cannot save what's left over. Measure carefully, according to the package directions.

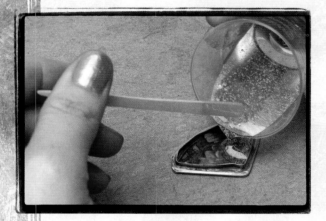

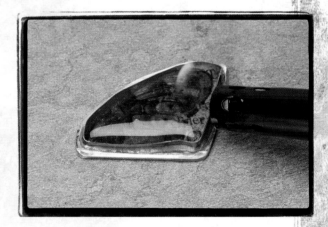

{5} Pour resin into bezel

Use a craft stick to thoroughly mix the two parts of the resin together for the time specified on the package. Pour the mixed resin into the bezel.

{6} Dislodge bubbles

Watch the piece for about twenty minutes. If any bubbles arise, dislodge them with a match or lighter, or by breathing warm air over the surface.

Who Knew?

If you are going to mix up a batch of resin, have several projects ready because you can't save what's left over. Be sure all of the objects are secured well with glue before adding the resin, or the objects may float loose.

Applying a Patina

There are many patina options available from manufacturers, or you can use a standard mixture of household ammonia and vinegar. I like using commercial products because they are ready to use. But when I need to allow something to sit in a solution for a day to a week, I often choose to make it myself using household products. The process of letting it sit for several days etches the metal and produces stronger and more brilliant results.

Secret Ingredients

sandpaper

old brush

patina solution (Modern Masters)

add-ons:
 laundry bluing
 table salt
 dried cilantro

{1} Sand metal
Using a piece of sandpaper, thoroughly sand all the areas of the metal that you want to accept the patina. After a good sanding the metal should appear dull and milky.

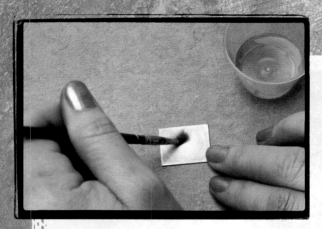

{2} Work in patina

Using an old brush, "scrub" the patina solution into the metal. The more you work it onto the surface, the more intense the color will be.

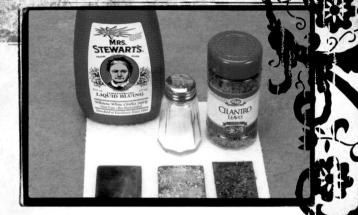

{3} Experiment with add-ons

After a patina solution has been brushed on, you can carry the process a step further by adding things to the top of it for more variations of texture and color. Additions used here, from left to right: laundry bluing, table salt and dried cilantro.

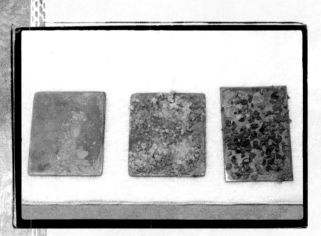

{4} Let patina sit overnight

This image shows how the patinas look after the solution has sat overnight.

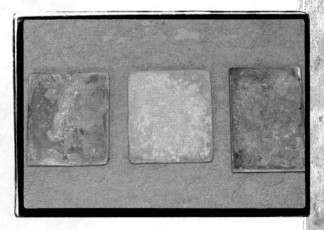

{5} Brush off add-ons

Lightly sweep off the additions with a dry brush or tap them off from behind to reveal a fancy altered surface. Lovely!

Etching Metal

Metal etching is a delightful and almost effortless process. There are several different ways to transfer an image to be etched onto metal. One way uses a rubber stamp and an ink pad such as StazOn to act as a resist to the etching solution. If you prefer, a red enamel paint pen can be used to draw directly onto the metal instead. The chemical I use to etch an image onto metal is ferric chloride. Also known in stores as PCB Etchant Solution, it can be found at electronics stores like Radio Shack or online.

Secret Ingredients

piece of base metal

rubber stamp

ink pad for metal or StazOn

heat gun

ferric chloride solution (PCB Etchant Solution)

small bowl

needle-nose pliers

paper towel

baking soda (for disposal)

patina solution and brush (optional)

{1} Sand and stamp metal

Clean the metal surface with simple soap and water first. Fingerprints will prevent the ink from sticking. Using either an ink pad for metal or a StazOn pad, stamp the desired image onto shiny (unsanded) metal.

{2} Heat-set ink

Heat-set the ink with a heat gun. This process can be sped up if you set the metal on a brick, because the brick does a great job of conducting the heat.

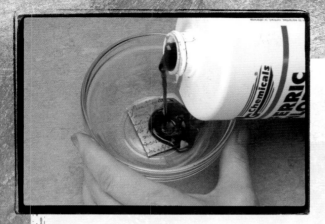

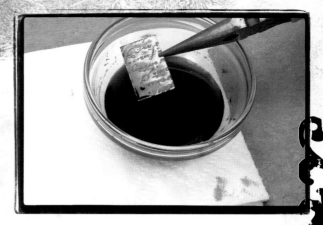

{3} Prepare solution

Using a glass or plastic bowl, pour some ferric chloride solution over the metal.

{4} Swirl metal in bowl

Leave the metal in the solution overnight. Remove the metal from the solution using pliers and set it on a paper towel. Run your pliers under water to remove the solution and dry with a paper towel.

Hint: *I like to set aside my container under a light for heat, which speeds up the process. I tend to come by every few hours, pick up the container and swirl the solution around. (The more you agitate it, the better the etch.)*

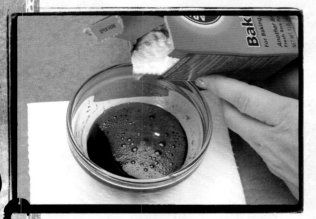

{5} Neutralize solution

Before disposing of the solution, add a few teaspoons of baking soda to neutralize the acid. It will foam up, so don't worry. It is now safe to pour into a trash container. **Do not** pour it down your sink, because it will etch your pipes.

{6} Add patina

Brush some patina solution over the etched metal piece. Note: After the patina is to the stage you want it and is dry, sand off the patina that's over the raised portion to reveal the etching. This will create a fantastic contrast between the image, which will become shiny, and the background, which will remain aged with patina.

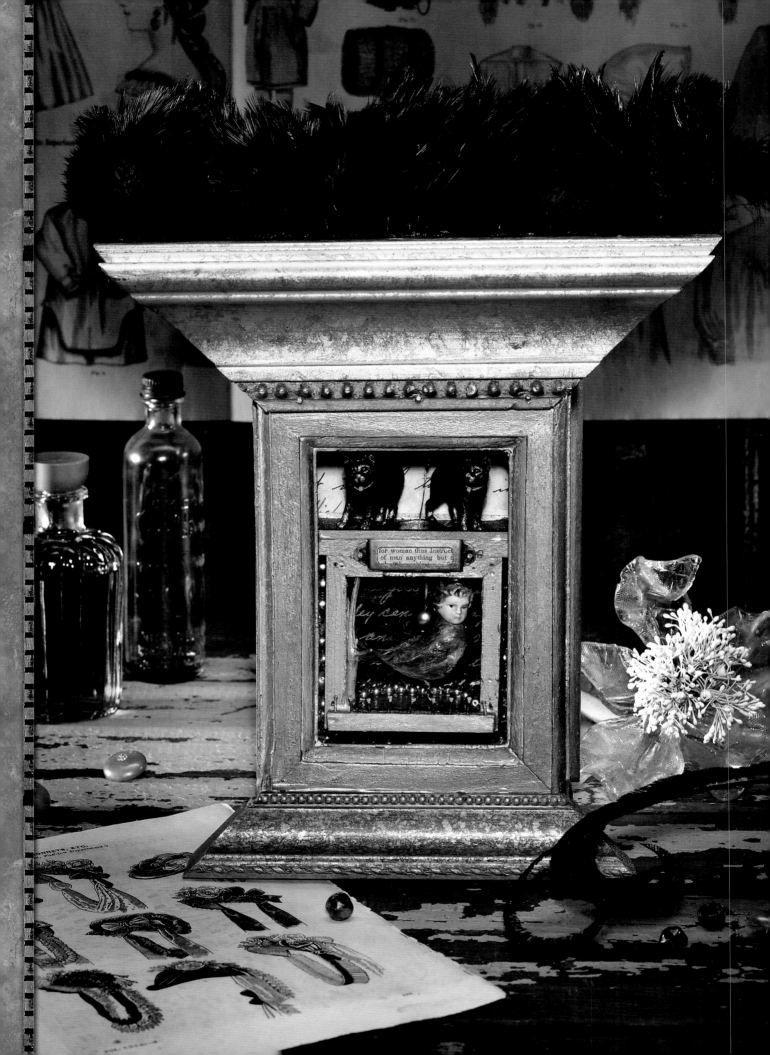

for woman thus instruct
of man anything but p

Storytelling

"Once upon a time . . ." is not as overused as it may seem—in fact, I find it quite catchy! When I begin creating a piece of art, I think about the finished piece, knowing I'll have only about seven seconds to make an impression. In those brief seven seconds, I need to say something intriguing to hold someone's attention. First, I look for clever ways to make a statement. From here, I begin weaving a story within the piece so that I hold their interest.

The way I do this is by working in an imaginary box otherwise known as my script. I set up my size and limitations in which I can make a statement. I then use an object as a focal point. This is the introduction.

Next, I create an environment for the object. This is the body of the piece. Depending on my message, I use similar objects or themes to create a sense of harmony. Other times, I create dissonance by using items that are unrelated or opposite to the focal point. This creates a strong juxtaposition and builds to a pinnacle point in the storytelling process.

Finally I deliver a punch line or conclusion with a simple "word" of text, or a sentence from an old book or newspaper that is the human voice or narrator in the piece. This adds direction and guides the viewer to form her own opinions on what she sees. Although I do not always add text to a piece, I find ways to make that same statement in a similar way by emphasizing something obvious to help with direction.

Once I have managed to work with these guidelines, and understand how to communicate with my audience, I look for new ways to break out of my box and do things that are truly unexpected.

"The end"

Personal Symbols and Such

Personal symbols develop over time. They are the things we reach for and are comfortable with, the things we most enjoy adding to a piece. Perhaps these symbols are nails on top of shrines, rows of tiny dots, or repeated images of birds; these are the personal signatures in your own work.

Sometimes we get our ideas from seeing others who create things in similar ways. This is appealing for a time, but after a while these symbols no longer seem special and we move on. For instance, over the last few years, everything in mixed-media artwork has sprouted wings. We see "wings" on everything from babies, to cats, to coffee cups!

I myself have a great fondness for rust. I have been rusting things for more than ten years. If it is new then I feel compelled to age it. I am not sure why I cannot be satisfied with things that appear new. Perhaps I just love things that are flawed and scuffed with age—they just hold more mystery. So, I age everything I can get my hands on. It has become my signature and I think I will never grow tired of the process.

So how do we begin to recognize our own personal symbols? By looking at several pieces of our work together and seeing what elements they all have in common. This meaning comes with confidence in yourself and your work, plus a little luck! As soon as we stop creating what we think others will like, we're well on our way. We experiment with materials, and with designs. We look for patterns in everyday life or try to tune into simple emotions. If you take a moment to really look at what you create, and ask yourself, "What is the real meaning of what I am making?" your answer will begin to surface. It takes a very deep breath and a simple quiet moment to be able to listen to what your work is saying. As artists, we get caught in a dangerous trap of trying to please our audience one hundred percent of the time. In my opinion, I think we need to first please ourselves before we can share ourselves with others. Once we trust ourselves and our skills, whatever we are making will appeal to others simply because it appeals to us.

Secret Design Recipe

What makes a piece of artwork unique?
What sets someone's art apart from someone else's?
How do I know that I am an artist?

I have asked myself these questions at one time or another. Every time I set out to create a work of art, I try to infuse my own feelings and emotions into it. The results are what make my pieces unique to me, and doing the same can make your work unique to you.

Practice makes perfect and brings confidence. The more work I make, the more confident I become. I learn to work out problems, discover what I like to use and what I don't, and begin to build my own vocabulary. All of this helps to develop a style.

If I go for more than a day without getting into my studio, I feel a strange sense of anxiety. On those days, I will at least find time to draw in my sketchbook or on the back of a sticky note! It keeps my eyes sharp, my hands warm and my brain working. Art making is a form of exercise.

Artist block happens to every artist at one time or another. What works for me when I am blocked for ideas is finding visual stimulation. I go to a library or a bookstore and pore over art history books. I spend dreamy hours living inside of deep dark paintings. I become transfixed with brushstrokes and dazed by the attention to subject matter. Crossed hands on a linen dress showing youthful fingers and painted with strict detail make me swoon. Deliberate gashes with a palette knife—which can dig into the canvas and spill Alizarin Crimson across the horizon—makes my heart skip a beat. The delicate construction of shadow boxes filled with paper images and medicine bottles lined up in a row with a quiet simplicity creates balance and dignity. I become alive with ideas and visions.

It is true that I look for inspiration by turning to other artists. I will stand for an easy hour in the magazine aisle and page through the many contemporary magazines on shelves. I have been known to cross over to other sections to see a magazine with a flashy photo or a clever design. When the rare moments occur, when nothing in print will satisfy my visual desires, I venture out to a museum or

On the occasion that I am not out and about looking at art, I can always visit virtual museums and galleries twenty-four hours a day. Some of the Web sites I frequent are:

American Visionary Art Museum | www.avam.org

Art Star Gallery | www.artstarphilly.com

Etsy | www.etsy.com

International Museum of Collage, Assemblage and Construction | www.collagemuseum.com

Jonathan LeVine Gallery | www.jonathanlevinegallery.com

Juxtapoz Magazine | www.juxtapoz.com

La Luz de Jesus Gallery | www.laluzdejesus.com

The Metropolitan Museum of Art | www.metmuseum.org

Museum of Modern Art (MoMA) | www.moma.org

Mütter Museum | www.collphyphil.org/mutter.asp

National Museum of Women in the Arts www.nmwa.org

Smithsonian | www.si.edu

Strychnin Gallery | www.strychnin.com

galleries and experience the real thing, face to face. There is nothing like seeing art in person. The barriers are no longer truly there and you can see a piece in its entirety. These are the moments when my skin begins to grow hot to the touch and I get a lump in my throat. Seeing art in the flesh can wash away any frustration you may have had.

I think the Internet is an amazing tool for reaching out to other artists, marketing your own work and getting great exposure. Don't hesitate to contact an artist whose work you admire via e-mail. You never know when you may create a very valuable and lasting friendship! When I was in grad school, a professor once said to me, "You are like one of those girls who goes to parties and wears all of her jewelry all at once." It meant I was adding too many elements to a piece of art, making it look cluttered and unresolved. At first I was overwhelmed with the remark and took it as an insult. After a while I understood what it meant and learned to be selective about what I wanted to say in a piece of art. I realized that it was better to hint at something than to say too much. Simplicity, I found out the hard way, was the most difficult thing to achieve. It was a true turning point for me and for my art. Sometimes messages come in thorny packages and sting deeply. I am happy to have my scar as a reminder of such a brilliantly difficult lesson.

The art-making process can be quite varied and not as organized as we might like it to be. When we sit down to begin making a piece of art, we often first see it in our mind. But where do ideas come from? Sometimes an idea will come to me in a dream or a passing vision. It can happen when I'm sitting in a restaurant and the quirky décor sparks something in my head. One season, while coming and going to work, I became fixated on a weather tracking station that was contained in a lovely wooden box in a field next to the road. I looked for it each day and I knew it would eventually find its way into my designs.

There are times when some of my ideas make it only as far as a page in my sketchbook. Frequently, when I am waiting in lines, offices or parking lots, I reach for my sketchbook and sketch out ideas. I carry a little Moleskine sketchbook and an extra-fine-point pen (which gives me an amazing amount of detail and allows me to write clearly) with me wherever I go. I build shrines on paper and design lovely pendants which hang on a page. It can be as much of an exercise to design something on paper as it is to build something by hand.

One challenge to account for when drawing is the finished, physical size of an object. Inevitably, unexpected situations will happen when you are building and assembling a piece. Paper and pen can be immune to these obstacles. I remember creating a very detailed shrine on paper once. When I started to build it, I discovered some unexpected limitations I had to work around. Although I was happy with the final outcome of the piece, it did not look exactly like the original drawing I made.

The design process does not always need to be plotted out on paper beforehand, however. Sometimes you may find it appealing to work more organically. There are many times when I hold an object in my hand and decide I will build something around it. It is then a matter of switching to hunt-and-gather mode. I look for things that will complement each other in some way. It can be as simple as matching colors or sizes. Other times I enjoy juxtaposing meanings. If something is soft and pretty, then I pair it with something dark, sharp or dangerous. If something is delicate, I balance it with something edgy or awkward. One secret to a successful piece of art is creating a dynamic dialogue between objects.

Color is another element of design that can hold a lot of meaning. Developing your own color palette is another way to expand your personal symbols and style. I love to work in muted vintage tones. I stick

to rust, aqua blue and green because they are the colors of aged metals. It helps set a mood and shows the passage of time. When I do use bold colors, I use the basic complementary color schemes, like red and green, blue and amber, and lavender and yellow. Using a spot of bold color creates a dramatic effect. Think about what meaning certain colors hold for you and how to use them to strengthen your message.

When I am walking the halls of a museum, I make sure I find my way to the rooms with African artifacts. Many years back, when I was doing some research for a paper in college, I wandered past some striking fetish sculptures from the people of the Congo Basin in Central Africa. Called nkisi, these objects were carved out of wood and depicted the human figure or an anthropomorphic hybrid. They were heavily adorned with a variety of rusted nails, blades and scraps of mirror. Upon further investigation, I learned the intentions of these dangerously sharp adornments were to warn evil spirits or to act as a protection against evil. These sculptures were created by the tribe's medicine man or spiritual leader and charged with various meaning and power such as divination, healing and prosperity. When translated, the term *nkisi* means sacred medicine. Since discovering these amazing and powerfully charged sculptures, I have used nails in my own work with the same intentions. The repetition of nails across a surface creates a visual harmony and provides attention to a piece. Try researching symbolic meanings on your own and replicate the things that resonate with you.

Repetition of a line or pattern can work to your advantage in unifying a piece of art. I often coat a shrine floor with a "puddle" of small pearls because it creates a dramatic detail. With something as small as pearls or nails, it is far more interesting to group many of them together, either in a line or as a cluster. Their size is small, but there is greatness in numbers.

Once, when I was sitting in a critique session in school, my professors suggested I try to work on a very large scale. They suggested I make art as tall as I was or beyond. After trying to better understand this concept of size and scale, I began drawing out some designs and writing thoughts in my sketchbook. I went in search of large objects to include in my giant work. I bought full sheets of wood and hammered and nailed, and cut and attached large items together. When I was finished, I had something that was a . . . disaster. It lacked patient aesthetics, it lost any intimate meaning, and it was void of passion. But, it was one of my greatest lessons. The process taught me to discover my true artistic voice. I knew I was more about telling secrets than about shouting out loud.

My work seems to require an intimate relationship with my audience. When you take a moment to look at something that is small, it requires coming closer to inspect it. The physical distance is narrowed and you have the full attention of yourself and your viewer. From that moment on, your message has changed from a statement to a dialogue. You can share an emotional moment and it becomes personal. I simply adore this intimacy in small works of art. For a short moment in time, there is a spiritual connection.

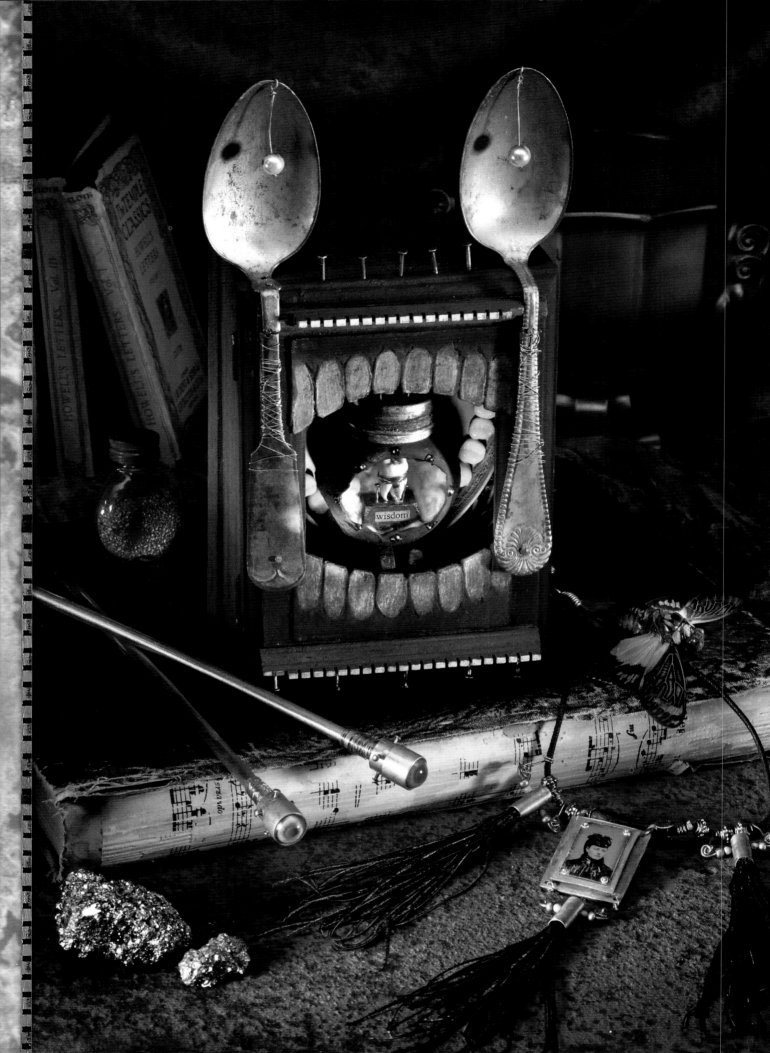

Projects

The physical creation of building a piece of art is only a small piece of the art puzzle. Until you create a unique story (regardless of how conceptual it is), and a personal history for your piece, you may struggle with calling what you make "art." All works of art need a soul. The story is the soul.

Stories can be created in a variety of ways. Sometimes stories are from your past, like memories—like a childhood toy, or an experience like being at the beach on a long, lazy afternoon. Other times, a story may come from the present and will motivate you to make something immediately. I have made pieces that have originated from an issue that was occurring in my life at the time I was creating it. It truly inspires a piece and gives it richness and emotion. It also can serve as a porthole to understanding your issues much better. And finally, for the dreamer in all of us, there is always the fantasy and the future. The stories from your imagination can be the brightest and most powerful, and always intriguing.

Learn to build an environment from your imagination. Capture a story and bring it to life with some intriguing techniques. Discover a variety of different ways to alter objects, transform surfaces and tap into your curious spirit.

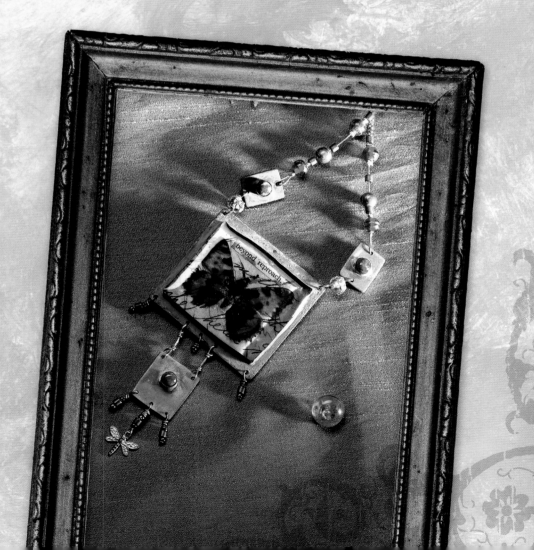

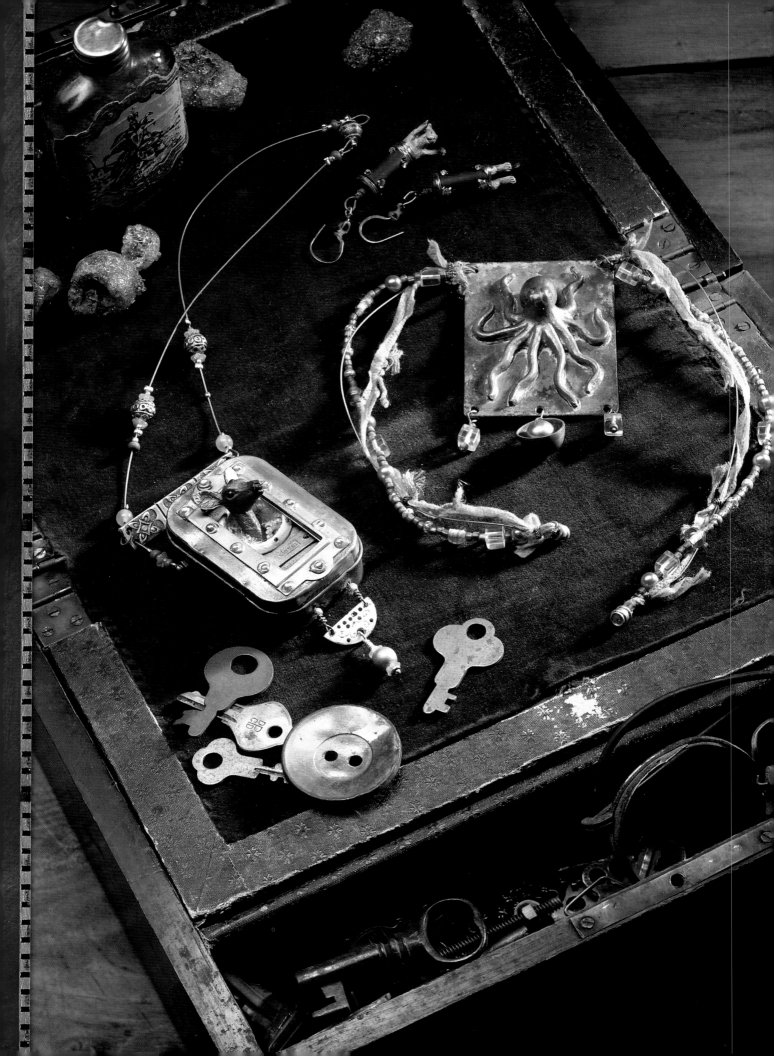

Adorn Yourself

JEWELRY WITH A STORY

I have always had a particular enthusiasm for jewelry. I see it as an artistic expression rather than something you wear to prove a point. There have been times in my life where the more I could wear, the better. I've never been much for wearing simple, tiny things either. While it has never been my wish to go over the top and wear something huge or tacky, I always prefer something interesting over commonplace.

I began to concentrate on making my own jewelry in grad school as a way to carry my art around with me all the time. I was finding myself out and about each week, going to art openings and gallery shows and being asked the question, "What kind of work do you do?" For me this question was always difficult to answer without having charts and diagrams on hand! So I would give a variety of answers and hope I had made sense. I thought that if I only had something on hand that I could show someone they would begin to really see the things I was trying to explain in words. So I decided to make little pieces of art to wear. My first was a piece of brass with a lovely aqua green patina, a tiny vintage image of "Melvin" (my husband's great-uncle) as a boy, the words "Hot Water" added to the bottom (an old machine hex nut), and a simple amber stone set in a bezel cup. It was my first, real found-object-collage piece of jewelry.

From the moment I wore that piece, I was asked countless questions about it. It was like walking around with a little art gallery of my very own. I loved the attention I received as a result of wearing it. In the pages that follow are several projects that will help you develop a secret dialogue for artistic expression and learn how to create your own wearable gallery of art.

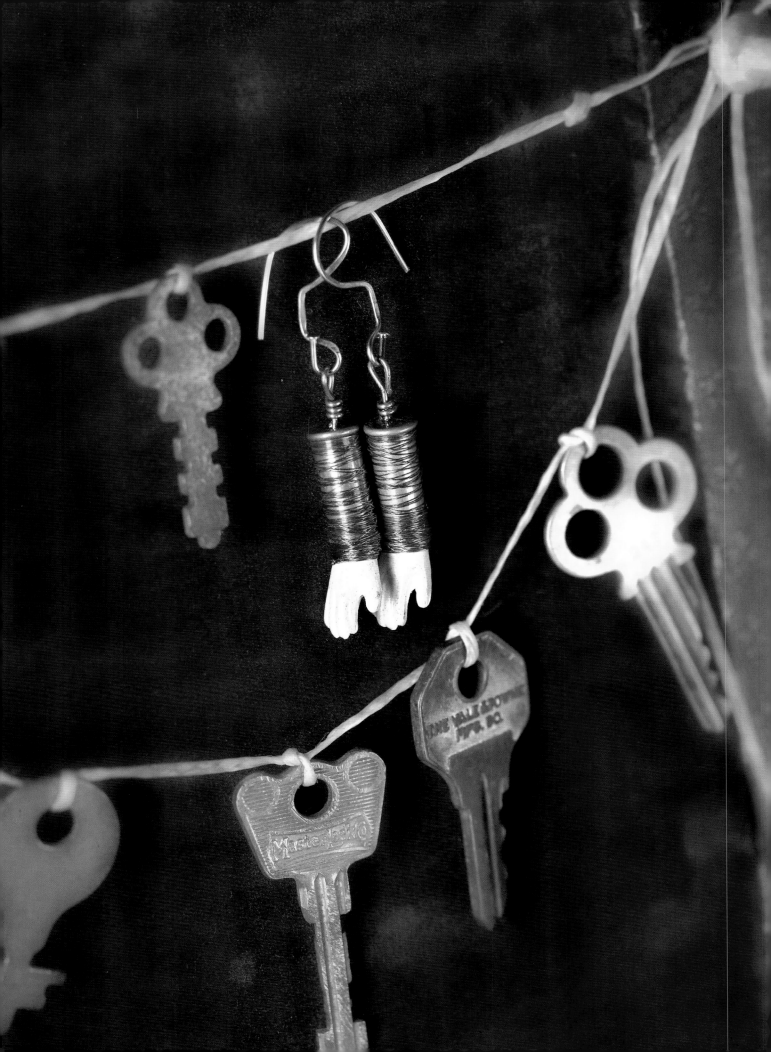

Bullet Casing *Earrings*

Being a pacifist at heart, I never expected to have anything to do with a gun in my lifetime. But one day, my best friend asked me to go with her to a Mensa meeting. This particular meeting was held at a local firing range! This seemed so odd that I said yes!

We learned about guns in a classroom, took our gun safety test, then were allowed to enter the shooting range. I felt ten feet tall and I loved the sense of power I had. It was similar to how I feel when I use power tools at home in my studio in that it took similar strength and concentration. When our day came to a close, I decided I wanted some mementos. I bent down and stuffed my pockets full of our spent brass bullet casings.

When I got home, I emptied the warm-colored casings into a jar and closed the lid. They sat there sealed for a long time. They have a powerful and, at times, negative meaning attached to them: violence, aggression, murder. How could I ever get past these images? One day, as I was working, it occurred to me that I could use those aged casings for jewelry. The only challenge would be offsetting their negative vibe with something equally as lighthearted. I decided to go with a toy. The whimsy of the toy would overshadow any negative connotations and allow it to become a piece of art—happy, silly, charming, youthful and innocent.

Secret Ingredients

empty bullet casings, two

drill or Dremel and ⅛" (3mm) bit

patina solution and brush

doll arms (cut off at forearm), two

ivory acrylic paint and brush

brush

head pins, two

small beads, two

very fine copper wire (such as electrical)

needle-nose pliers

paper towel

epoxy

wire cutters

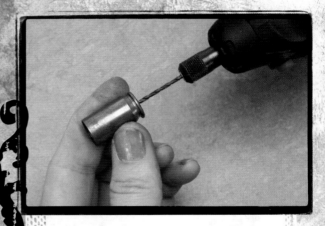

{1} Drill hole
Drill a hole in the divot of the cap at the end of each bullet casing.

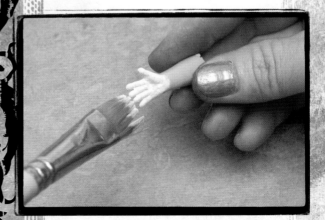

{2} Paint doll parts
Add a patina to the casing and set aside. Apply ivory or white paint to two doll hands that have been trimmed to fit the casings.

45

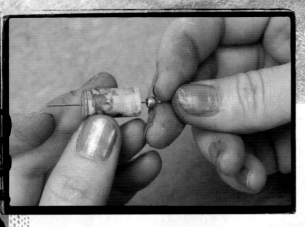

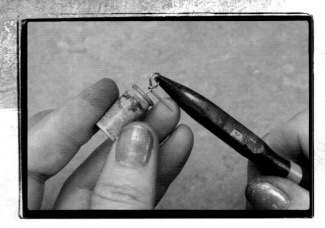

{3} Thread a stopper bead

Insert a head pin into a small bead, and then through the inside of a casing, so that the pin's wire goes through the drilled hole.

{4} Create loop

With the wire pulled taut against the bead on the inside, use pliers to create a loop near the cap of the casing. Wrap the remaining pin wire around it.

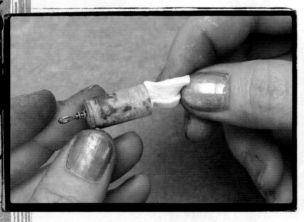

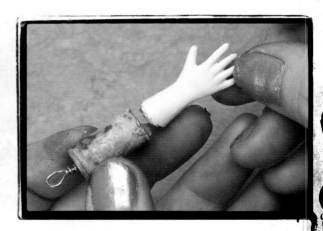

{5} Add paper towel

Push a small wad of paper towel into the casing.

{6} Insert doll part

Apply epoxy to the end of the painted doll hand and insert it into the casing, pushing it into the paper towel.

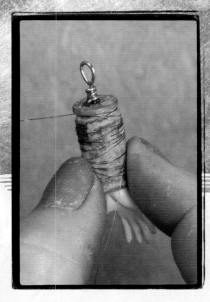

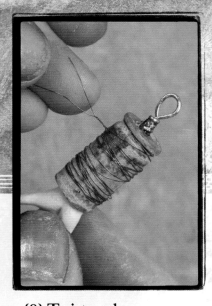

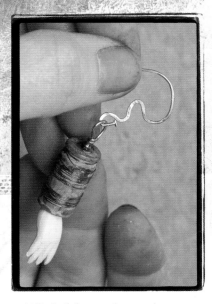

{7} Wrap casings

Repeat for the other casing, then wrap the casings with fine copper wire. (You can buy this wire with electrical supplies.)

{8} Twist ends

When you have wrapped the piece with an amount of wire you're happy with, twist the ends together to secure.

{9} Add earring wire

Trim the excess wire, then conceal the ends in the wrapped strands. Create an earring wire (see page 48) and add it to the loop at the end of the casing.

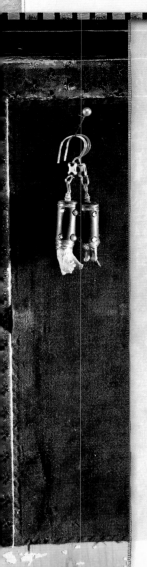

Extra Hands

Perhaps it is because I work with my hands all the time that I have grown fond of using hand imagery in my work. I have gathered a rather large collection of doll hands for several years. Sometimes at flea markets I find little plastic bags filled with these tiny appendages. It is so sad to think there are so many dolls missing arms out there!

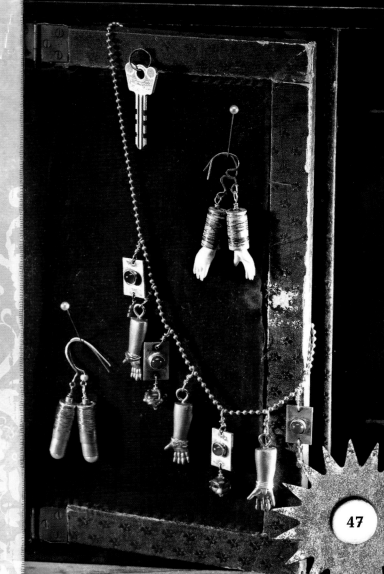

Creating Earring Wires

When making a pair of earrings, do not overlook the obvious: the earring wires. It is very easy to make your own out of wire or a long head pin or eye pin. With a few quick twists and a little hammering, you will give your creations a unique and fully handmade feel.

Secret Ingredients

20-gauge wire head pin

bent-nose pliers

small toy or object

hammer

anvil

wire cutters

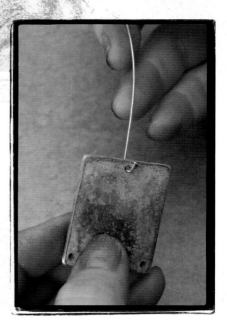

{2} Thread through hole
Thread the end through the hole on your metal or other object.

To use with a drilled hole

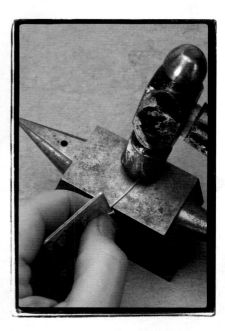

{1} Bend head pin
Take a head pin or wire and bend it with a pair of bent-nose pliers.

{3} Hammer wire
Flatten the wire with a hammer on an anvil.

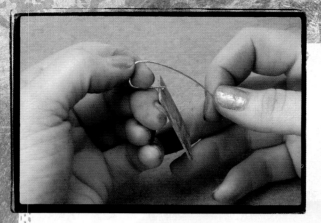

{4} Bend flattened wire
Bend the flattened wire to create the earring wire.

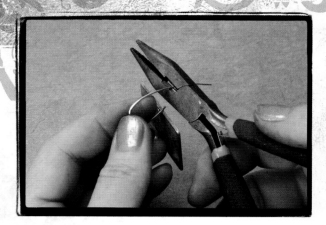

{5} Trim excess
Trim off the excess wire.

To use with a jump ring or dangle

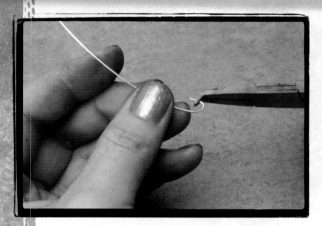

{1} Loop pin at head end
Start with a head pin and make a loop at the head-end of the pin.

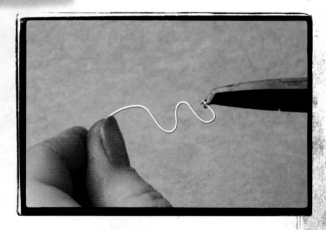

{2} Make squiggle
Use bent-nose pliers to bend a squiggle into the wire and create the ear loop.

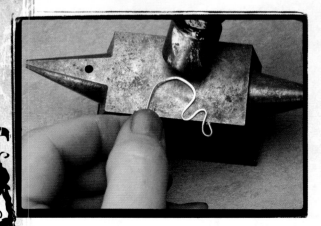

{3} Hammer wire
Hammer the wire flat with a hammer and an anvil.

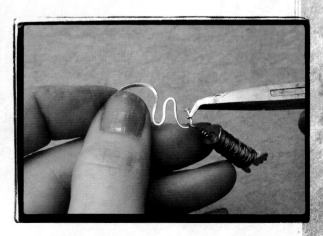

{4} Add dangle
Attach the dangle to the small loop-end. Then squeeze shut.

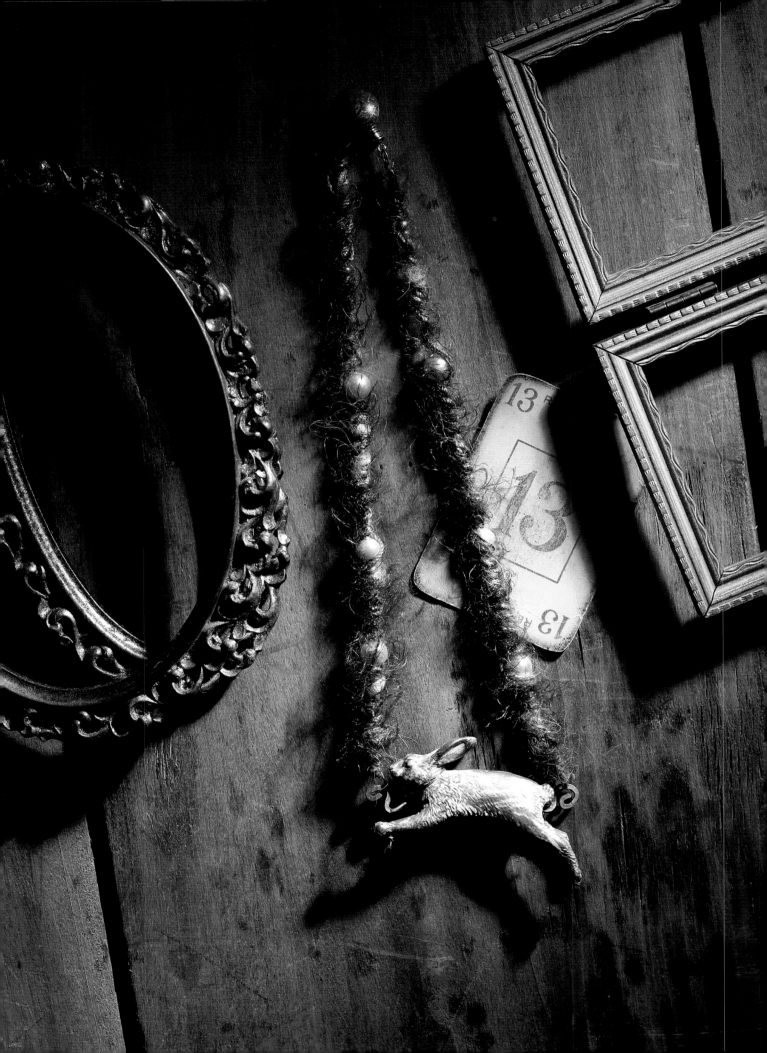

Running Bunny
Necklace

Rabbits have always held magic and significant meaning to me. On many occasions, I've been charmed by these creatures and their hypnotizing stares and twitching noses. When I was younger, I spent time in the spring and summer evenings at twilight watching the bunnies come out to play. I used to think they were the little messengers for the Fey folk, and would dart around carrying important gossip from one end of town to the other.

On certain evenings, if I was quiet enough, and could lie very still on my stomach, I could catch a glimpse of them letting their guard down. They would move without hesitation, go about eating the tall, sweet grass and frolic effortlessly. But the moment I would move, or become distracted by a passing lightning bug, they would sense I was watching and become very still. I was always the first to become impatient and would rise up for a better look. At that point, the rabbits would race across the field, hide in the trees and thickets and stay hidden until it was safe, dark and moonlit. I would then have to wait for a new evening to see them.

Secret Ingredients

beading wire (SoftFlex), 28" (71cm)

novelty yarns (two varieties),
48" (1m) each

large crimping beads

pliers

pearl beads, assorted sizes

clasp

plastic bunny

drill or Dremel tool and
⅛" (3mm) bit

ivory acrylic paint and brush

patina solution and brush

⅛" (3mm) hobby pipe

pipe cutter

clothesline wire

hammer

anvil

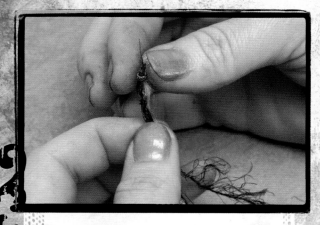

{1} Thread crimp bead
Trim the length of wire into two 14"
(36cm) pieces and the yarn into four 24"
(61cm) pieces. Thread one end of the
beading wire and two strands of yarn
through a crimping bead.

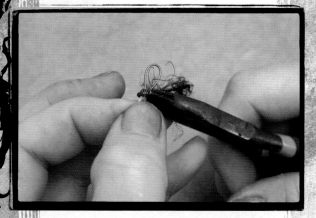

{2} Crimp
Loop the wire and run it back through the
bead, then crimp with pliers.

51

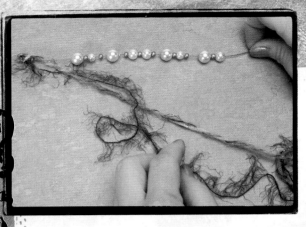

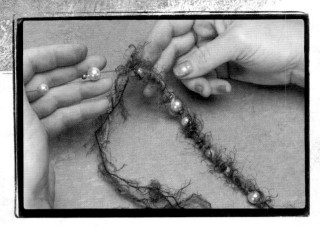

{3} String pearls

String about a dozen pearls onto the wire, in any order of size.

{4} Twist fibers

Begin twisting the fibers around the wire, randomly sliding pearls up to be included between wraps.

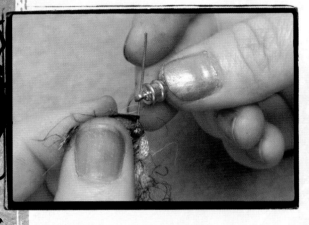

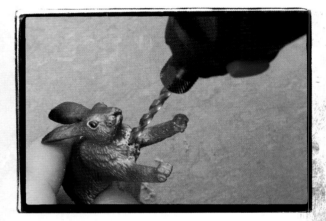

{5} Thread crimp bead

When the entire length of the fiber has been used, thread it and the wire through another large crimping bead and the end of the clasp. Run the wire back through the bead, leaving a small loop.

{6} Drill hole in rabbit

Crimp the bead and set the necklace strands aside. Using a Dremel tool, carefully drill a hole through the plastic rabbit.

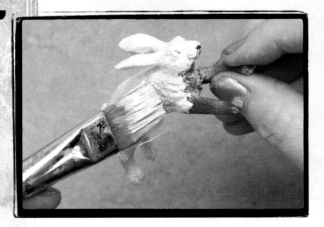

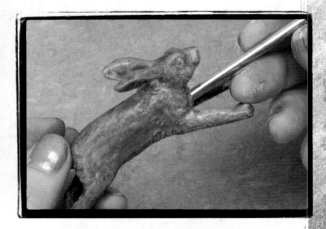

{7} Paint rabbit

Apply a coat of ivory paint to the entire rabbit and let dry.

{8} Measure hobby pipe

Paint the entire rabbit with gold metallic paint, and when dry add a patina (see Applying a Patina, page 30). Insert the hobby pipe into the rabbit and mark how long it needs to be. It should be the exact length of the hole in the rabbit.

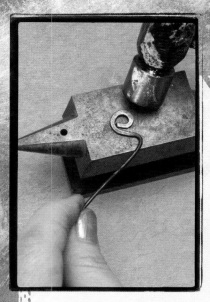

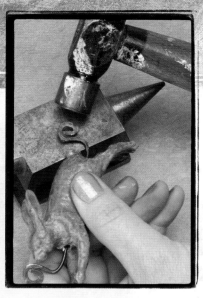

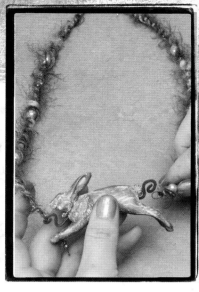

{9} Thread rabbit

Remove the pipe and trim it, using a pipe cutter. Insert the pipe back into the rabbit. Cut a 5" (13cm) length of clothesline wire. Create a loop at one end, followed by a sharp bend. Hammer the S-shape to flatten it slightly, then insert the wire through one end of the rabbit.

{10} Flatten other end of wire

Bend the wire protruding from the opposite end of the tube and flatten it as well.

{11} Attach strands

The loops of the strands can now be threaded onto the rabbit's wire.

Delightful Dumpling

Who would think that a plastic pig could look so important? With a bit of altering, some gold and bronze paint, and a keen combination of baubles and gems, this delightful dumpling transforms into a lovely wearable art piece.

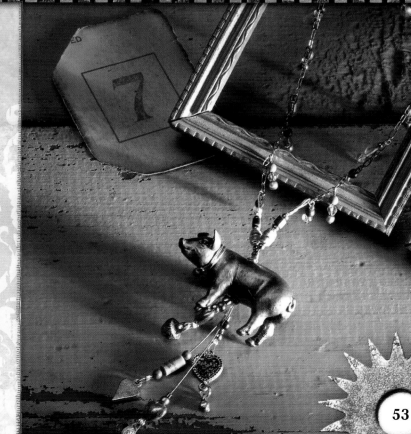

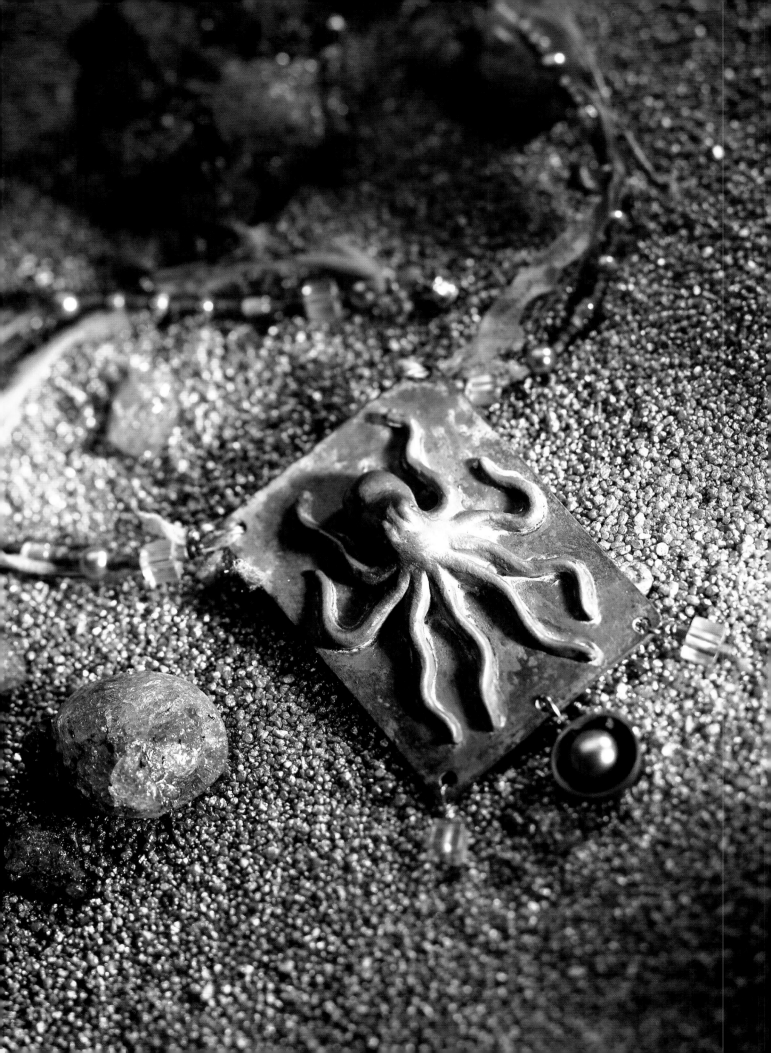

Octopus Necklace

One evening, I was invited to dinner at a Japanese restaurant. It was a simple, small place with traditional accents of bamboo, and an occasional fan or two hung on a pale pink wall. We ordered dinner salads along with sushi. When the salads arrived, I was stricken with paralysis when a small bowl of lovely, deep, rich green sesame seaweed was set in front of me.

Amidst the greens were large slices of fresh octopus tentacles. Panic grew inside of me. I didn't want emotion to show on my face as I sat and listened to the conversation. Oh, that poor enchanting creature was sacrificed for a lousy dinner salad. Such a fresh kill, its rubbery wet skin seemed to glow and almost move. It was the most beautiful thing I had ever seen and yet I felt as if I was the only witness to a murder scene that was laid out in front of me on the table.

I picked around the salad, trying to appear nonchalant. Then, without hesitation, I did something that Ms. Manners would not approve of. I waited for a moment when no one was looking and took a large pink tentacle from the dish, placed it into a wad of napkins, and stuffed it deep inside my purse. In my mind, I thought I could save this tiny piece as evidence of a tragic event—a lovely creature ripped from its home in the sea. I believed I could bring honor to its untimely death in some way. It was my way of coping with death.

I took it home, placed it on my computer scanner and documented it. The color was fading and the smell of the ocean was being replaced by a stinging odor of decay. I wrapped it up carefully in fresh paper towels, and then in a brown paper bag. Two days later, I returned to check on it. It was no longer pink and delicate, and now resembled a small, shriveled mushroom. The smell was overpowering. I quickly closed the bag, took it to a safe place out in the studio, and let it sit on a cool, dry shelf. When I returned to it two months later, it had finished curing, but in a way I had not expected. It was formless—dust to the touch—gone.

I mourn the unnecessary death of that octopus to this very day. In memory, I have taken up the octopus as my personal symbol and I do what I can to find ways to celebrate my clever and complex companion.

Secret Ingredients

non-drying polymer clay

two-part mold putty (Alumilite)

two-part resin

craft knife

copper sheet

drill or Dremel with ⅛" (3mm) bit

metallic paint

patina solution and brush

epoxy

small metal cup (see page 18)

head pins, three

assorted glass beads

beading wire (SoftFlex) 28" (71cm)

novelty yarns (two varieties), 48" (1m) ea.

large crimping beads

pliers

clasp

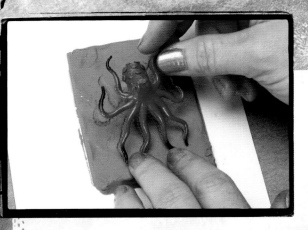

{1} Push object into clay

To make a base for the object to be cast, use non-drying polymer clay. Slightly push the toy object into the clay.

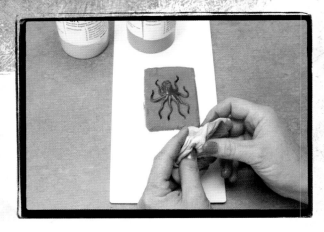

{2} Mix compound

Squeeze enough equal parts of the two-part compound to cover your toy. Mix by kneading them together until it's an even color.

{3} Form mold

Push the kneaded compound onto the toy and its base to form a mold.

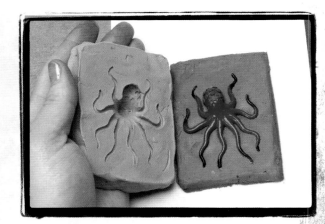

{4} Release object

Set it aside to cure for the amount of time specified on the manufacturer's package. Then, release it from the object.

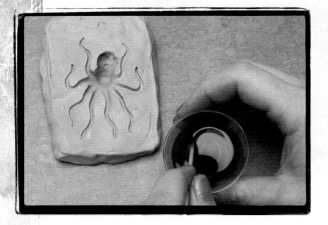

{5} Mix resin

Measure out equal parts of two-part resin, enough to fill the mold. Stir the mixture together with a craft stick.

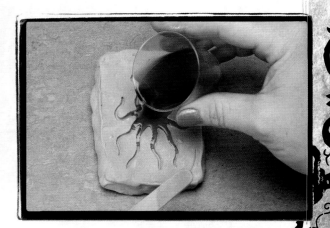

{6} Fill mold

Make sure the mold is on a level surface, then fill the mold with the mixed resin.

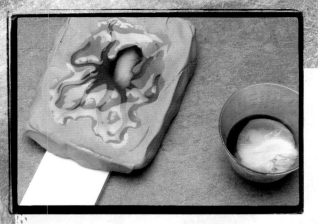

{7} Allow resin to harden
It will begin to harden right away!

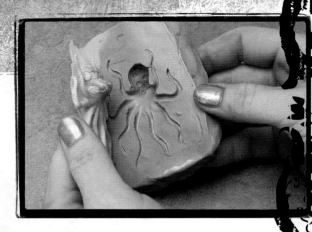

{8} Pop out solid resin
When the resin is completely solid, pop it out of the mold.

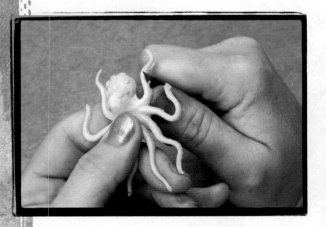

{9} Clean up edges
Use a craft knife to trim excess bits of the resin that make the toy appear shaggy.

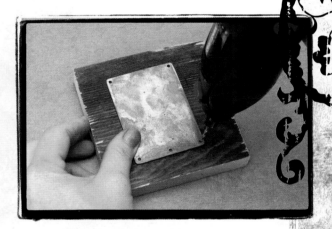

{10} Drill holes in copper
Drill five holes into a piece of copper—two at the top and three at the bottom.

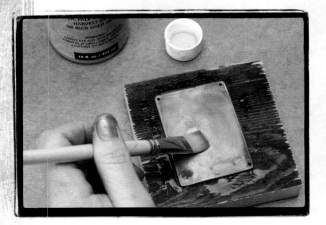

{11} Add patina
Apply a patina to the copper. Let dry.

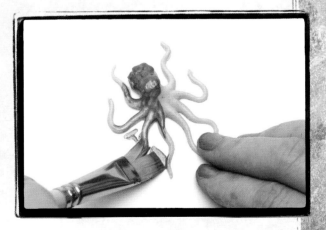

{12} Paint resin
Paint the cast toy with metal paint. Let dry.

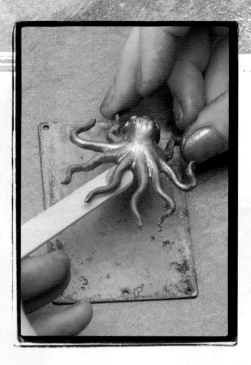

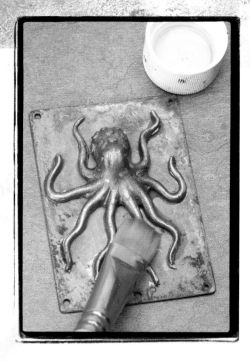

{13} Adhere toy to copper

Adhere the toy to the copper piece, using epoxy.

{14} Add patina

Apply a patina over the octopus. Let dry.

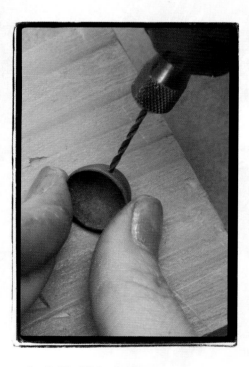

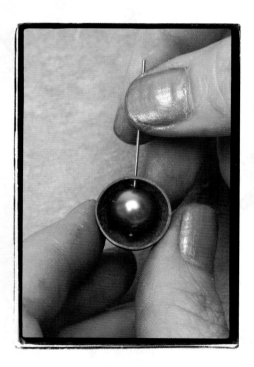

{15} Drill hole in cup

For a dangle at the bottom, create a tiny brass cup (see page 18) and add a patina to the inside. Drill a hole at the edge. You may want to secure the cup in a vise to drill into it.

{16} Add pearl

Insert a head pin through a pearl, then through the hole in the cup.

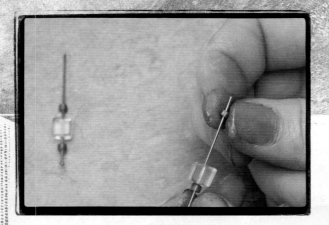

{17} Add more dangles

Make two additional dangles for the bottom, using another head pin and three beads.

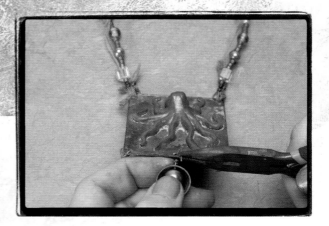

{18} Create beaded strands

Wire-wrap the beaded dangles from the bottom corner holes of the octopus piece, and the cup and pearl from the center hole. To hang the pendant, use either beading floss, wire or cable to create beaded strands and tie them to the top two corners of the octopus. (See Running Bunny Necklace, page 50.)

Under the Sea

You may attract a fish or two with this lovely necklace! At the very least, you are sure to get a lot of attention and compliments when you wear these unusual little altered toys.

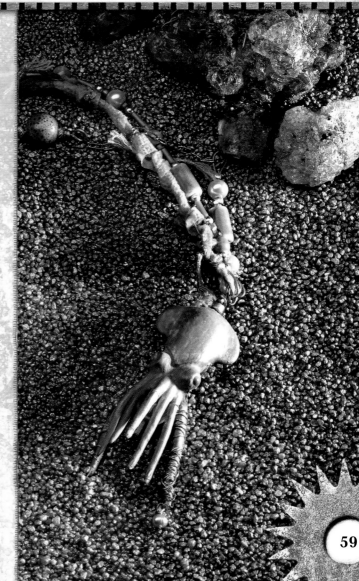

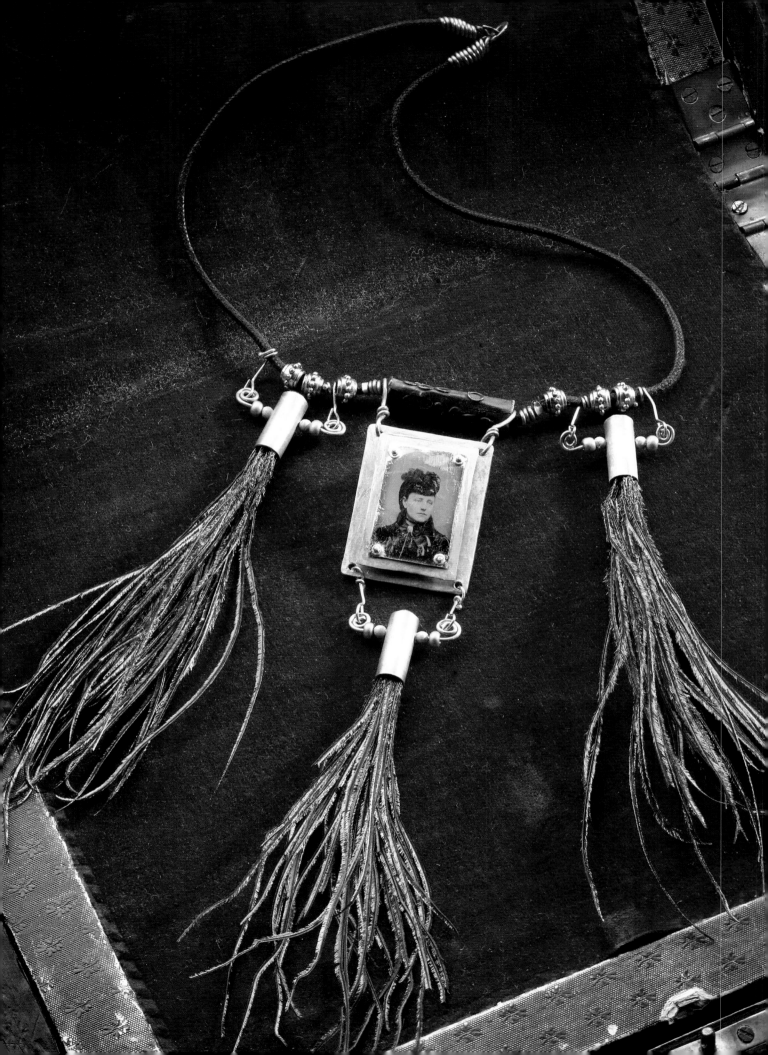

Industrial Peacock
Necklace

I really enjoy the challenge of combining organic objects and manmade items. It is always a hard-fought battle to be successful in keeping a balance between the two. I find that you need to create a harmony between both elements without allowing one to overpower the other. When I first started to work with this concept of man vs. nature, I knew I would work with a fabricated piece of metal pipe. I wanted the piece to have an industrial design feel to it. At the same time, I went in search for something natural. I have always loved the mysticism of peacock feathers, and I am even more enchanted by their metallic green and gold colors. I've united the two together in a necklace—one that is both soothing in texture and yet complicated to the eye.

Secret Ingredients

peacock feathers

scissors

epoxy

craft stick

hobby pipe

pipe cutter

bezel stones to fit diameter of pipe

vise

drill with ⅛" (3mm) bit

copper wire

16-gauge brass wire

assorted beads

head pin

tintype or other focal element

silk or leather cord

round-nose pliers

wire cutters

anvil

hammer

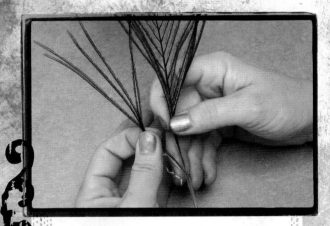

{1} Pluck strands
Pluck several individual strands from a peacock feather.

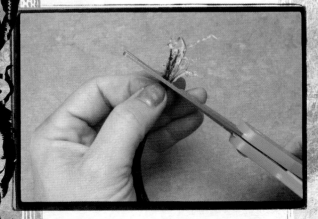

{2} Trim ends
When you have a substantial bunch, hold the cluster together and trim the ends flush with scissors.

61

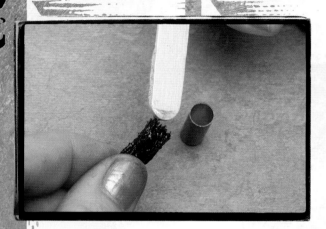

{3} Add epoxy

Use a craft stick to apply a glob of epoxy to the trimmed end of the cluster.

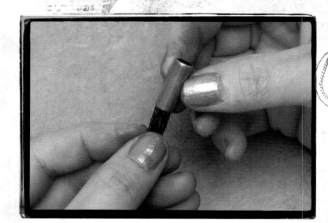

{4} Slide into pipe

Trim a piece of hobby pipe to 1" (3cm), using a pipe cutter (see page 23). Gently slide over the end of the cluster while the epoxy is still warm. Slide the cluster in until it is about ⅛" (3mm) from the other end of the pipe.

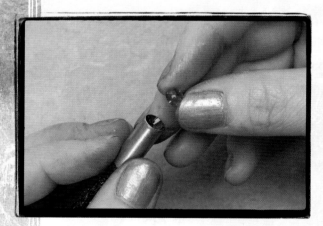

{5} Set stone

Dab a tiny bit of epoxy in the open end of the pipe, then set in the stone. Set aside until cured.

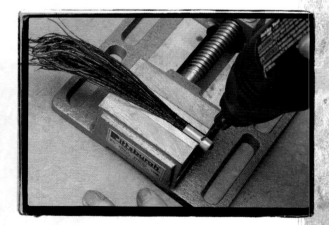

{6} Drill holes

Secure the pipe in a vise and drill a hole ³⁄₁₆" (5mm) from the edges. Drill one on each side.

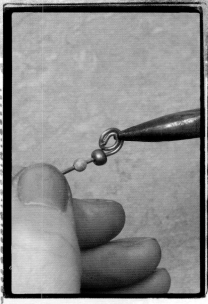

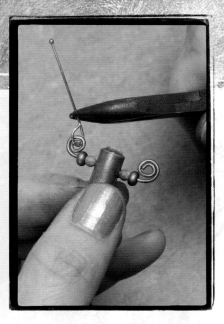

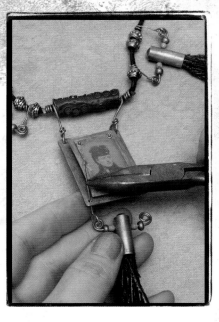

{7} Coil wire

Cut a 3" (8cm) length of copper wire. Use round-nose pliers to coil one end, then add a bead.

{8} Loop head pin

Thread the wire through the pipe, add a bead and coil the opposite end. At the end of a head pin, make a loop and thread the loop through the center of one of the coils.

{9} Create focal piece

Repeat for the other side, and create two more feather pieces. Create a focal point piece for the center of the necklace. Here I secured a tintype to a piece of brass and layered it onto a larger piece of brass (see Binding Metal with Epoxy, page 20). Then, I drilled holes in the top to secure it with wire, and at the bottom, I drilled two holes to hang a feather piece from it.

{10} Loop wire

Trim off a piece of 5" (13cm) wire. Make a small loop at one end.

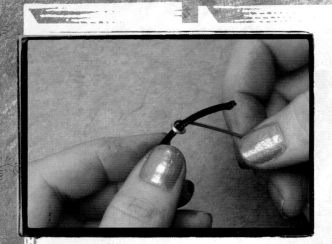

{11} Add cord

Thread the cord through the loop, leaving a 1" (3cm) tail.

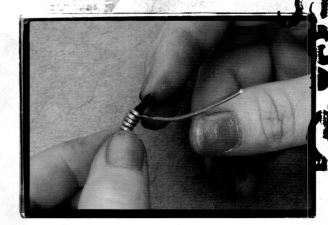

{12} Coil wire

Begin coiling the wire around the 1" (3cm) tail for about ½" (13mm). Periodically squeeze the coils together to keep the spiral tight.

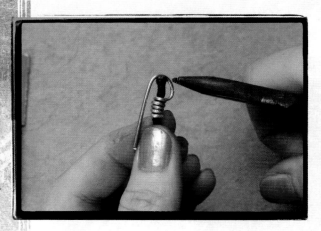

{13} Straighten loop

Bend the first loop straight up.

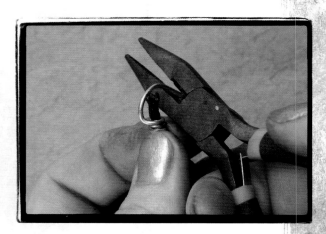

{14} Trim

Trim off the excess wire with wire cutters.

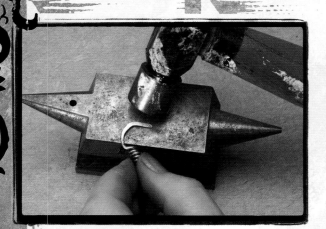

{15} Hammer wire

Hammer the loop on an anvil, flattening it.

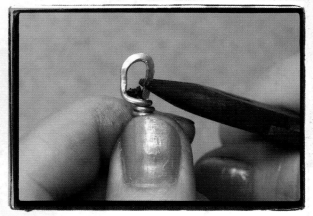

{16} Conceal wire end

Using the pliers, force the end of the wire on the loop inside the coil to conceal it.

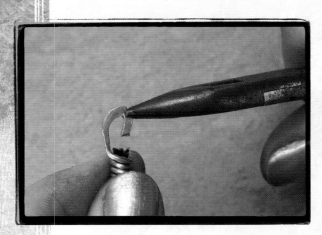

{17} Form hook

Repeat steps 1 through 6 for the other side of the necklace, but after you hammer it, open the loop up just a bit, trim off about ⅛" (3mm), then kink the end to form a hook.

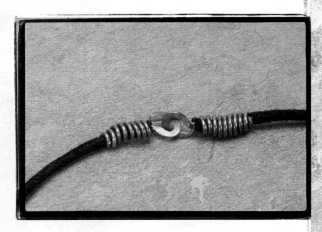

{18} Ensure clasp closes correctly

The necklace is now ready to wear!

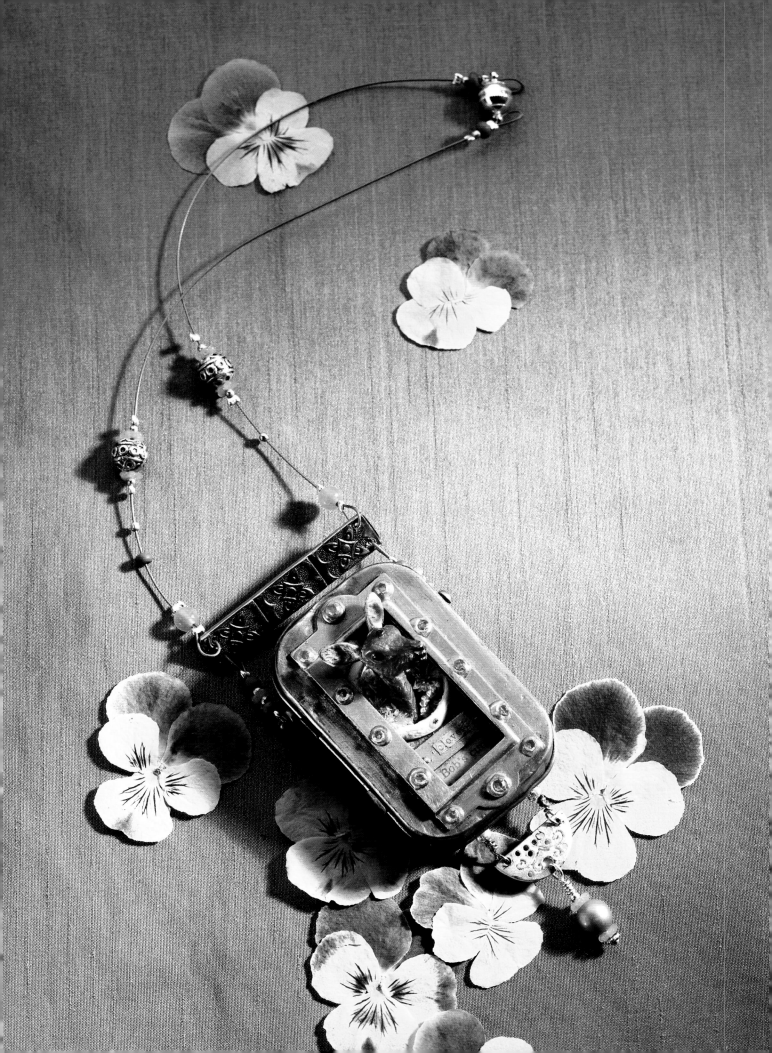

Peeking Deer
Necklace

The inspiration for this project came from a trip to a local flea market, where I stumbled upon a curious-looking booth. I picked out a few simple things to purchase, and was continuing my way around the crowded booth, skirting a stack of old record albums. It was then that I spied the most amazing object—a small taxidermy deer head mounted on a wooden plaque. Normally I detest these displays of cruelty, but this one was so different that I almost laughed out loud. This deer was peeking out from behind a sheer silk scarf that was carefully tied around her head and a ring of plastic flowers, purposefully hung around her neck. As I stepped in to get a better look, I almost jumped out of my skin. I had not noticed her—the pretty elderly woman, sitting so quietly in her chair, smiling at me. I stepped back, returning the smile, and said that I loved her deer and pointed behind her. She did not look. I wasn't sure if she had heard me or not; she just continued to smile. I handed her my things and paid in cash, keeping my eye on the deer the whole time, soaking in the humor.

As I got ready to turn to leave, I heard a quiet voice say, "I love her, too, now that she's dressed for the occasion." A warm feeling melted right through my body and I knew that I got her joke.

Secret Ingredients

mini mint tin	plastic deer
grill or heat gun	short nail
tiny bolts and hex nuts	dried flowers
needle tool	spoon
basswood	hacksaw
small piece of mat board	drill and ¹⁄₁₆" (2mm) bit
small piece of paper	rhinestones
craft knife	label plate
two-part epoxy	SoftFlex wire
pull cap	metallic paint and brush
ivory paint and brush	

{1} Add nuts to tin

Remove the paint from a mint tin by placing it in a grill for several minutes, or by heating it with a heat gun. Remove the lid from the tin, and using the needle tool, make two holes: on each side of the tin, near the top and back. Secure a bolt into each hole, using a nut on each side of the tin.

{2} Add spacers

Cut two small strips of basswood to use as spacers, and attach them with two-part epoxy to the bottom of the tin.

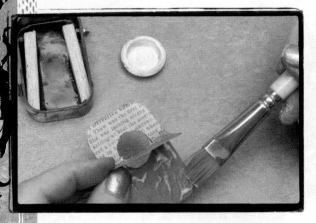

{3} Create background

Cut a piece of mat board and a piece of decorative paper to the size of the tin interior. Cut a hole in the top center of each. Glue the paper to the mat board.

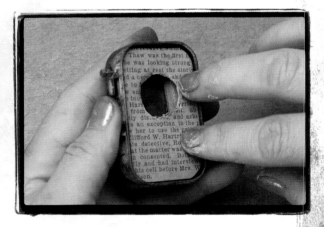

{4} Add background to tin

Adhere the text piece over the spacers in the tin.

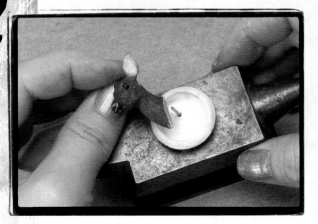

{5} Mount head to cup

Use a needle tool to make a hole in the center of the pull cap. Paint the cap with ivory paint and let dry. Cut the head of the deer off at the neck, leaving as long of a neck as possible. Insert a short nail through the back of the cup and push the deer head onto the nail.

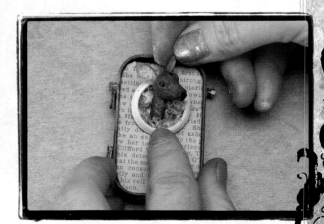

{6} Add cup to tin

Add some dried flowers around the neck of the deer, then use epoxy to glue the cup into the hole in the paper inside the tin.

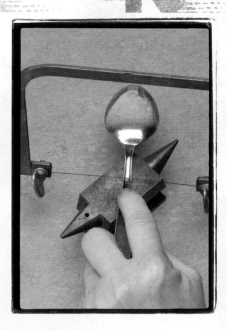

{7} Cut spoon

Using a hacksaw, trim a section out of a spoon to use as a wire connector.

{8} Drill holes

Drill a hole into each of the four corners of the spoon piece, using a $\frac{1}{16}"$ (2mm) drill bit.

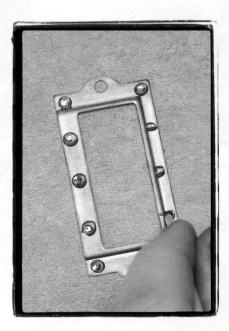

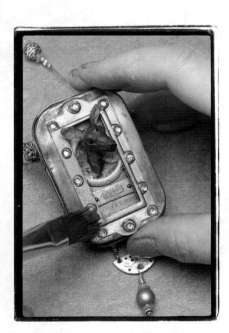

{9} Create label plate

Embellish a label plate with tiny stones by setting each in a small dab of two-part epoxy. Let dry.

{10} Add final embellishments

Finish adding embellishments like text or additional paint to the tin interior. Then, using SoftFlex wire, create the strand portion of the necklace, incorporating the piece from the spoon at the top of the tin. Adhere the embellished plate with the stones to the front of the tin, then add metallic paint around the stones to high-light the epoxy as a setting.

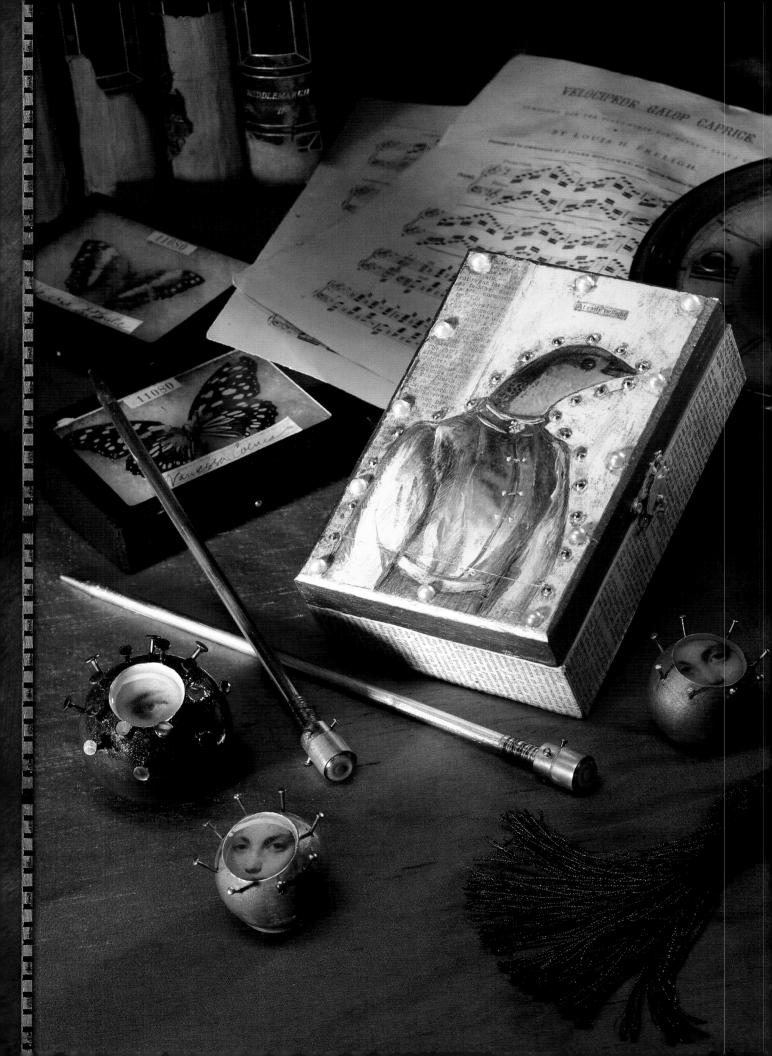

Entice a Friend

TOKENS TO SHARE

Giving handmade gifts means everything to me. The time, effort, money and skill it takes to make something by hand is by far a more endearing expression of love than something mass-produced. If you stop to think about the person who chooses to make fudge in her kitchen, you need to take into consideration how much time and effort went into actually making it. Once you think about it, you appreciate it all the more when you realize it would have been far easier to have just bought fudge at the local bakery.

I grew up with a lot of handmade gifts. My mother sewed and knitted clothes and toys every holiday season. It wasn't until recently (now that I am so much older and wiser) that I began to think about the wonderful, warm, thick, cable-knit sweaters I wore in those early winter months and realized how wonderful they truly were—especially now that I've I started to knit myself! (It does not come easy to me.)

These next few projects are enjoyable and simple gifts you can create in a day or two. They are all unusual conversation pieces and will create a flurry of wonderment and discussion when you share them with your dear ones.

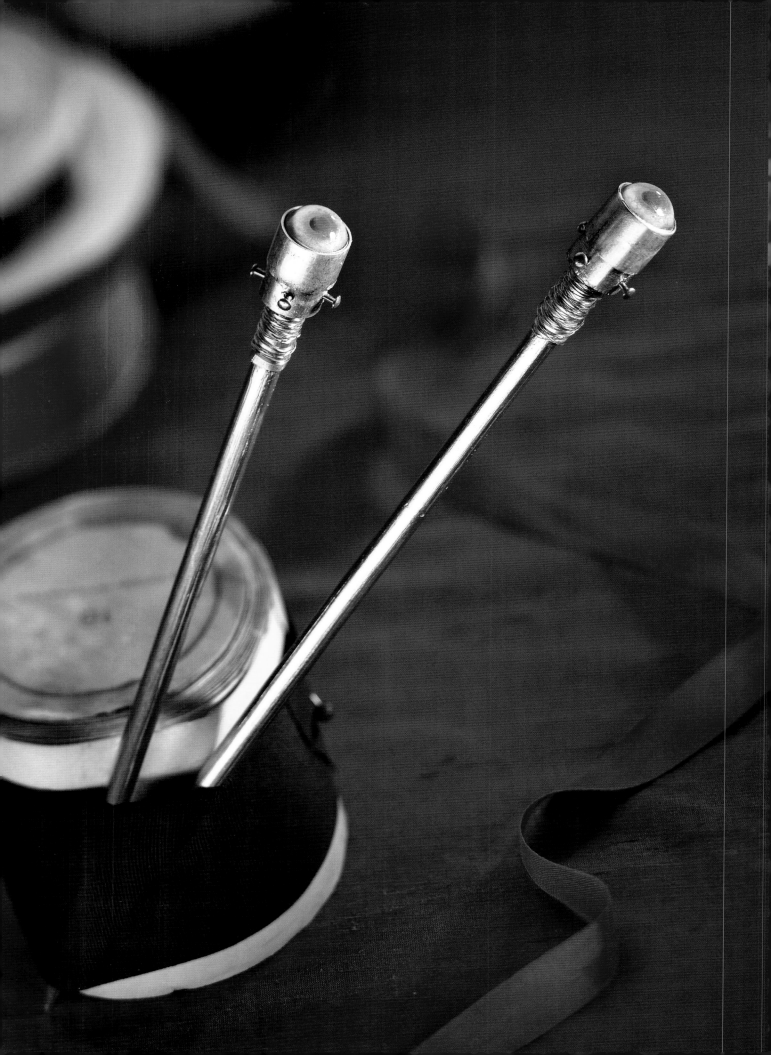

Hair Sticks

No more distressed tresses! I have been growing my hair long just so I will be able to wear even more adornments, because I can't have enough jewels. I have always loved hair sticks, and yet I find it odd and humorous—the idea of taking something pointy and wrapping hair around it in such a way that it holds tight. It's like wearing a puzzle.

I decided to make these hair sticks from simple bamboo knitting needles. I like the rather large knob at the top and the smooth, soft point at the bottom. I decided to find a way to give them some of my personality—like a signature of sorts. Of course I thought of using nails; however, I was afraid to construct something dangerous with nails jutting out, so I created a way to use them with great finesse.

Secret Ingredients

US 10 (6mm) knitting needle (wood)

gold metallic paint and brush

hobby pipe

pipe cutter

two-part epoxy

cotton swab

drill and 1/16" (2mm) bit

tiny brass nails

hammer

taxidermy eyes or round bezel gems

paper towel

{1} Paint needle

Paint the needle with a thin coat of gold metallic paint. Let dry.

{2} Cut section of pipe

Cut a length of pipe that just barely fits over the diameter of the needle to 3/8" (9mm) (see page 23). Using a cotton swab, apply some two-part epoxy to the interior of the pipe.

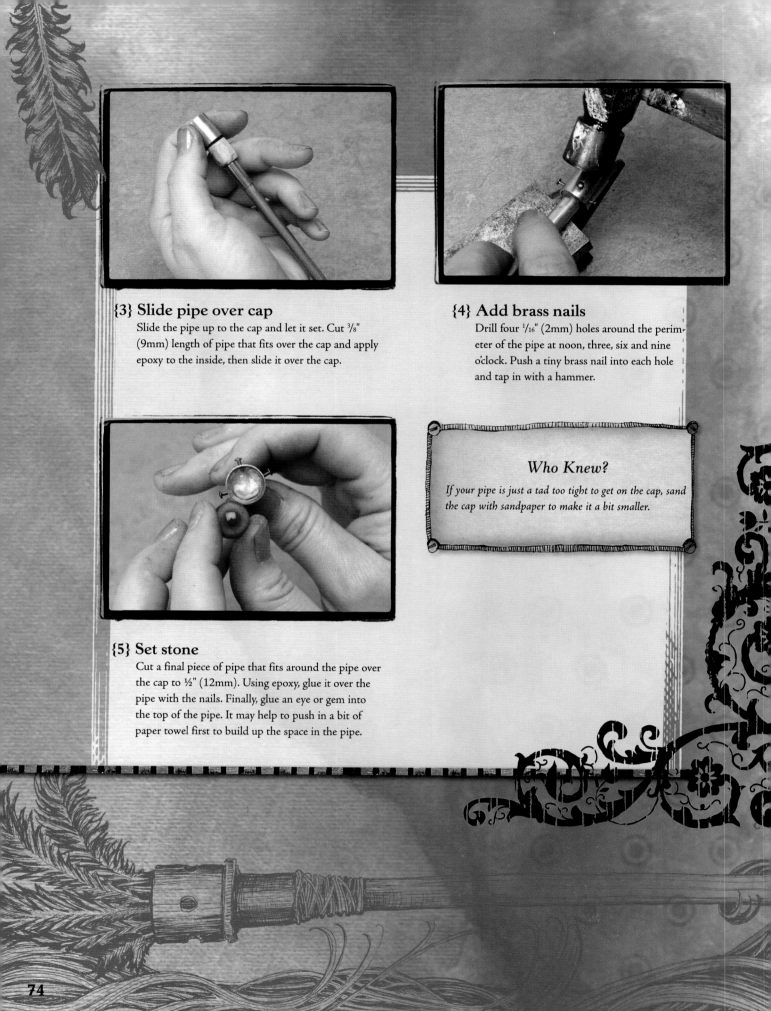

{3} Slide pipe over cap

Slide the pipe up to the cap and let it set. Cut ³⁄₈"
(9mm) length of pipe that fits over the cap and apply
epoxy to the inside, then slide it over the cap.

{4} Add brass nails

Drill four ¹⁄₁₆" (2mm) holes around the perim-
eter of the pipe at noon, three, six and nine
o'clock. Push a tiny brass nail into each hole
and tap in with a hammer.

Who Knew?

*If your pipe is just a tad too tight to get on the cap, sand
the cap with sandpaper to make it a bit smaller.*

{5} Set stone

Cut a final piece of pipe that fits around the pipe over
the cap to ½" (12mm). Using epoxy, glue it over the
pipe with the nails. Finally, glue an eye or gem into
the top of the pipe. It may help to push in a bit of
paper towel first to build up the space in the pipe.

Metalicious

Working with metal knitting needles is
not as intimidating as it seems. You can
alter them by adding a little metal piece
of brass tubing to the top with solder.
Adorn them with some fancy feathers,
an old button or a romantic gem.

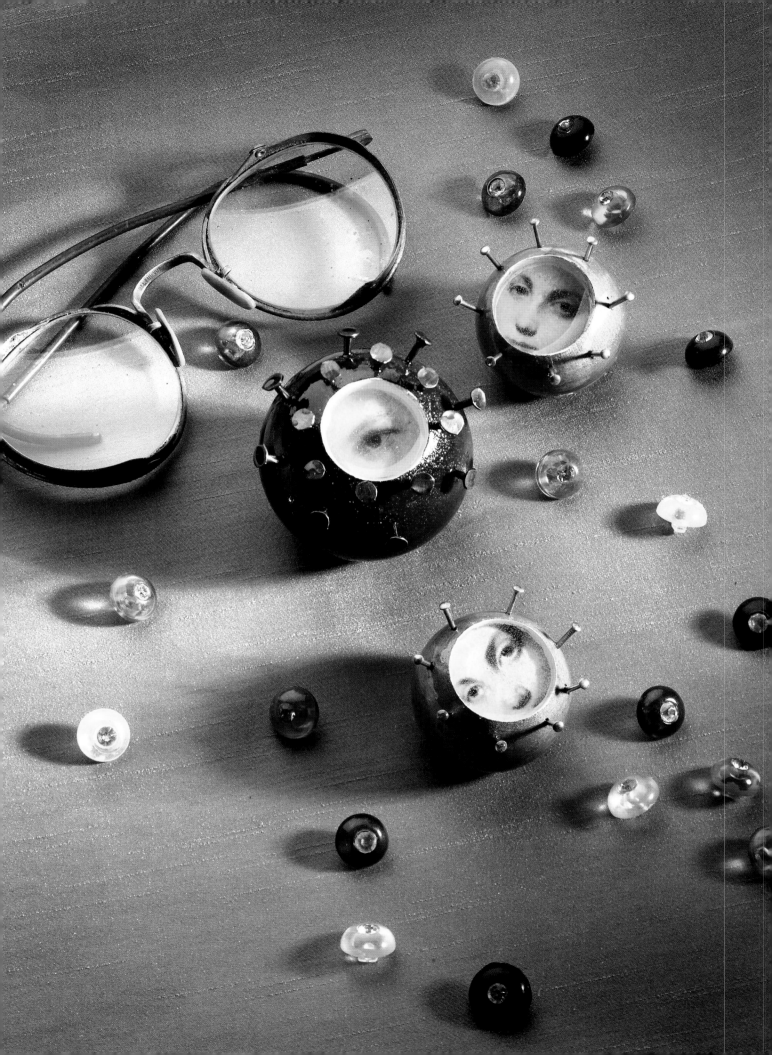

Drawer Pulls

Pouring resin is like pouring syrup on pancakes! I have a great love of both. While searching for places where I could add a little unexpected touch of art, I looked to the furniture in my home. I knew I could take something like a knob and make it come to life by giving it a personality. That is the kind of whimsy I want to live with—the fantasy that you read about in children's books or fairytales: "She was the most demure and charming bureau I had ever met . . ."

Secret Ingredients

wood knobs

router bit and drill (size appropriate to knob size)

ivory acrylic paint and brush

gold metallic paint

patina solution

small brass nails

image

white glue

two-part resin (Envirotex Lite)

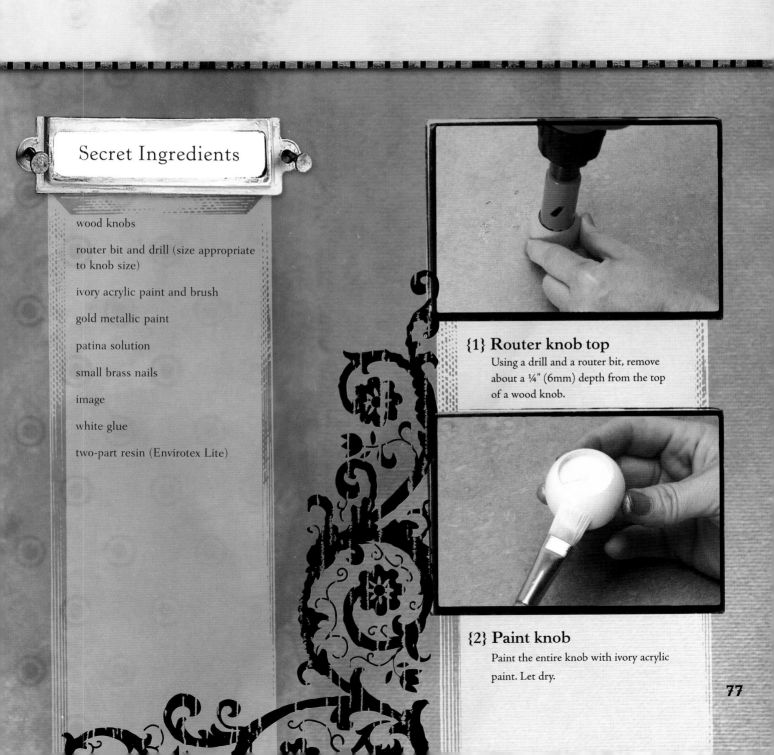

{1} Router knob top
Using a drill and a router bit, remove about a ¼" (6mm) depth from the top of a wood knob.

{2} Paint knob
Paint the entire knob with ivory acrylic paint. Let dry.

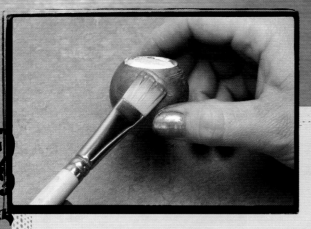

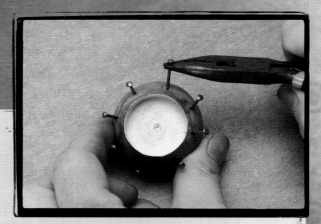

{3} Add metallic paint

Give the perimeter of the knob a coat of gold metallic paint, avoiding the portion that was routed out.

{4} Add patina and nails

Apply a solution of patina and let dry. Add little brass nails around the perimeter of the routed opening. Don't worry if they're not perfect.

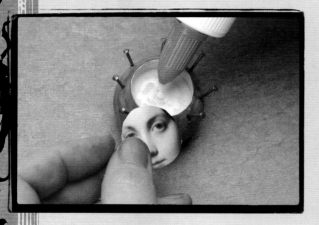

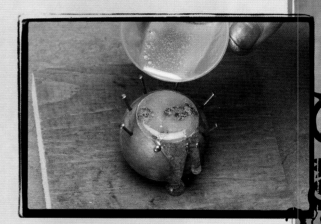

{5} Adhere image

Cut out an image to fit in the routed-out area. Adhere with white glue. Be sure the image is glued down completely.

{6} Fill hole with resin

Mix up a small batch of resin according to the manufacturer's directions, and pour it into the knob. Pour out enough to slightly overfill the depth, so it runs over the sides. Let the resin cure, then attach the finished knob to a drawer.

Beloved Immortal

Resin is a brilliant medium with many possibilities. It can take on many uses, from a common drawer pull with artsy flair to an elaborate pendant that captures a delicate butterfly or even just a single wing.

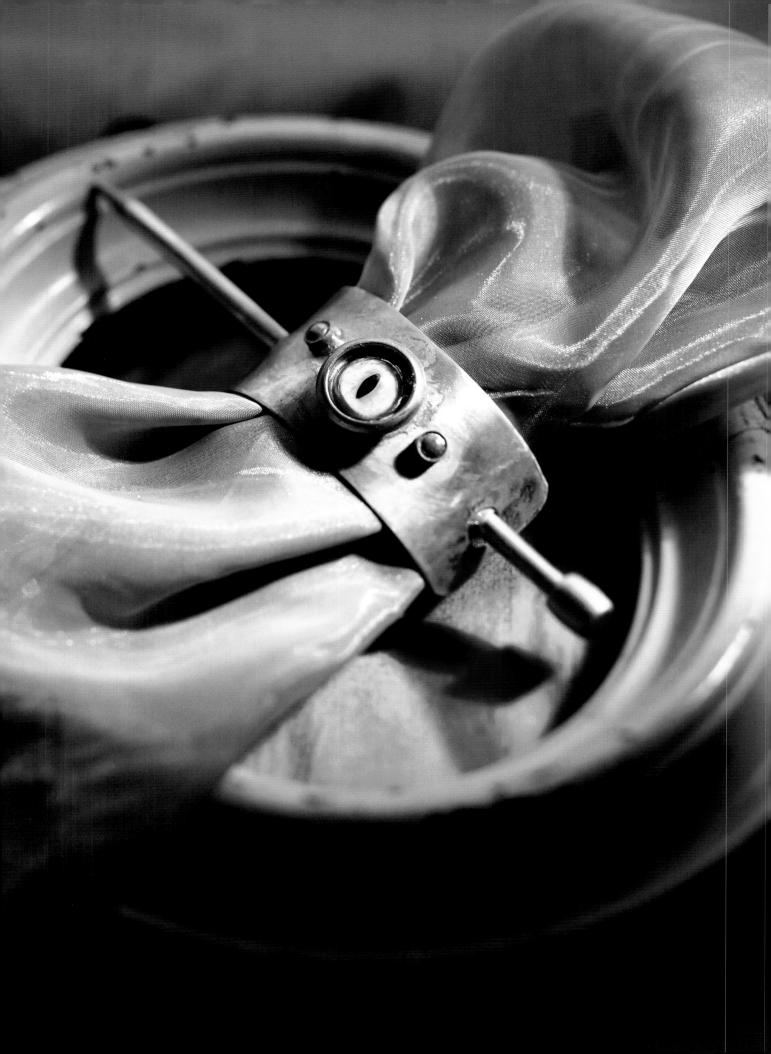

Barrette

My mother used to tell me she had eyes in the back of her head so I would behave myself in public situations. She has a long mane and I actually believed that she had eyes buried somewhere in all of that hair. Sometimes when she was sitting still I would wait and watch and then do something naughty just to see if it was true. She caught me every time. Mothers have a very keen sense of power over children and a fine-tuned intuition. I loved her clever manipulations and wild stories. They made life more interesting. What better way to control what you see behind you than to give yourself an extra set of eyes?

Secret Ingredients

- metal barrette base (or sheet metal cut to size, rounded corners)
- permanent marker
- drill with ⁵⁄₁₆" (8mm) bit
- file
- hammer and anvil
- propane torch
- soldering screen and stand
- pliers
- bowl of water
- liquid flux
- silver solder
- pull cap
- ⅛" (3mm) hobby pipe
- pipe cutter
- 400-grit wet sandpaper
- two-part epoxy
- taxidermy eyes and round bezel stones

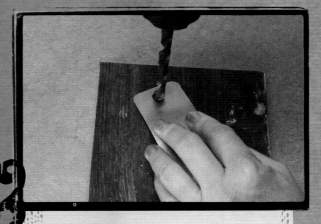

{1} Drill holes

Use a permanent marker to mark a hole on either end of the metal about ⁵⁄₁₆" (8mm) in, then drill the holes.

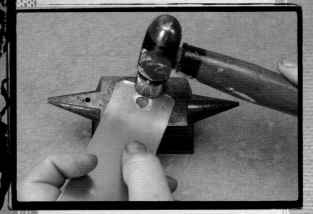

{2} Smooth the metal

File the holes to remove any unwanted burs. Then hammer the holes to really smooth them out.

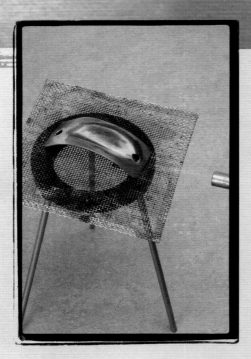

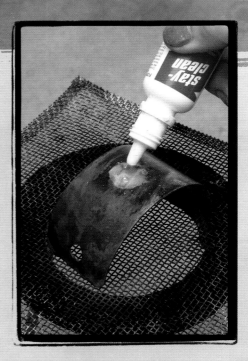

{3} Heat metal

If you are not using a prefabricated barrette piece of metal, bend your piece slightly so it arches. Set the metal on a soldering screen and stand and heat the metal with a torch to alter the surface. Heat it for about three minutes.

{4} Shape and reheat

Using pliers, drop the metal into a bowl of water. Remove it from the water and bend it further into a nice, curved shape. It will be easy to do this while it's still warm. Set the piece back on the stand and heat up the metal again for about 30 seconds. Place a drop of flux onto the center of the metal.

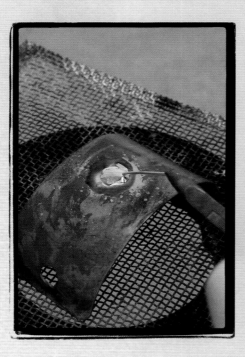

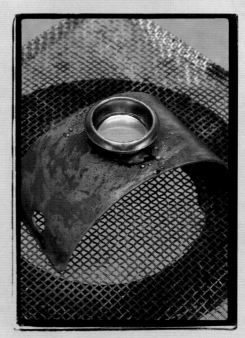

{5} Add solder

Create a small pool of solder over the fluxed area.

{6} Add cap

Press on the pull cap, using pliers. Heat it again to age the pull cap, then hold it in place for a few seconds, with pliers, while the solder cures.

{7} Add circular bezels

Dunk the piece in water again. Cut two pieces of pipe to about $\frac{3}{16}$" (5mm) using a pipe cutter. Set the metal back on the stand, and heat the area to one side of the cup. Add a drop of solder and then set one pipe piece into it and add a bit of solder to secure the pipe to the metal. Then, repeat for the other side.

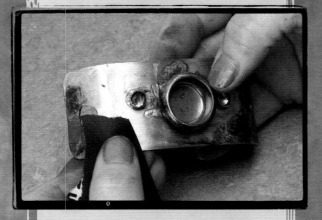

{8} Polish metal

Cool the piece in water, then sand the piece with wet sandpaper to bring back just a tiny bit of the brass color to some areas.

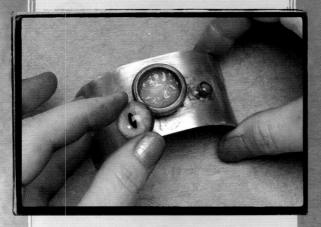

{9} Set stones

Use epoxy to adhere the gems and eye into the bezels to finish.

That's Odd!

You can use a wooden knitting needle for the barrette stick. Simply cut off a couple of inches from the pointed end and re-sharpen it in a pencil sharpener. Paint or stain the stick as desired.

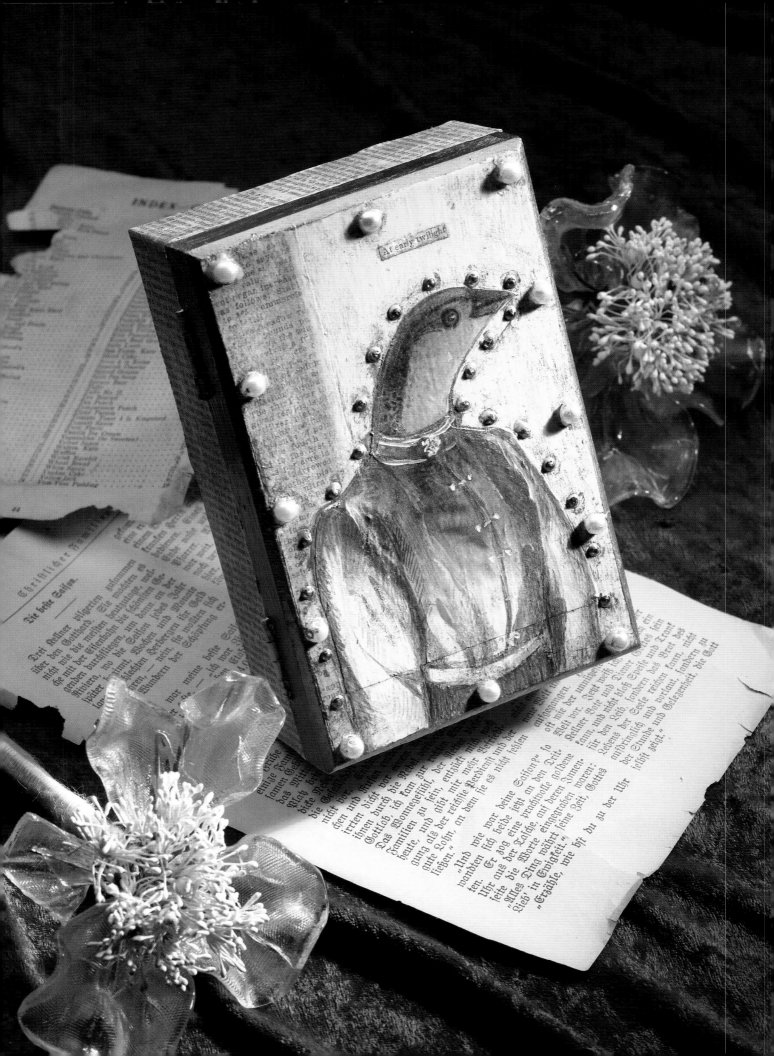

Collaged Box

There is something very intriguing and absurd about blending images of humans and animals together in different ways. This combination has piqued my interest since I was a child. It started with Beatrix Potter stories of little animals wearing clothes and talking. I fell in love with the idea of animal play-mates. I used to look carefully at my cats and wait to hear them speak. I was convinced they would talk to me one day. (I still am.) So, when I started looking into the art and history of anthropomorphic images, I realized I had tapped into a very common subject, dating back to Egyptian times and continuing up through modern-day advertising. Pants on pandas, suits on sea gulls and cats in hats—all humorous and delightful.

When I began to create my box, I knew I wanted to create a very dignified ladybird. I did a little research to help my efforts and discovered that there was an Egyptian god, Thoth, who was the god of the moon, magic and writing. He was usually depicted with the head of an ibis (bird) and the body of a man. I imagined his wife would have had a lovely jewelry box, so I decided to make a box in her honor. I took the image of a bird and one of an elegant lady, cut and pasted them together, and created what I like to call Mrs. Thoth's Jewelry Box.

Secret Ingredients

wood jewelry box

ivory acrylic paint

paper towel

gold metallic paint

brush

patina solution and brush

clear sealer

paper images

découpage medium

pencil

decorative paper

drill and ³⁄₁₆" (5mm) bit

two-part epoxy

craft stick

pearls

crystals

85

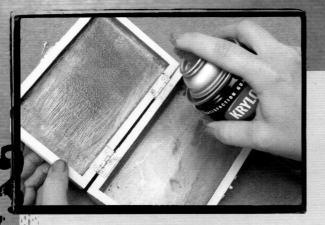

{1} Apply patina to box

Paint the entire box with ivory paint. When it's dry, add gold metallic paint to the interior. Let dry, then brush a patina onto the interior as well. When the patina is dry, spray the interior with a clear sealer and then let that dry.

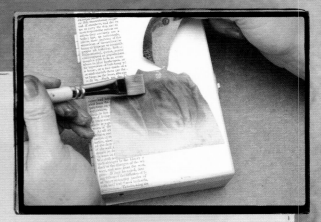

{2} Découpage images

Begin découpaging the outside of the box with your chosen images. Here I decided to morph a bird's head on a woman's body.

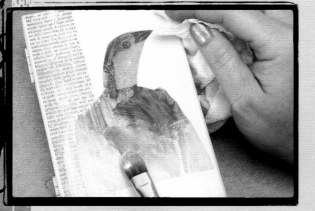

{3} White-wash images

Lightly brush a thin coat of ivory paint over all of the imagery, then use a paper towel to immediately wipe off the paint over the areas you most want to remain visible.

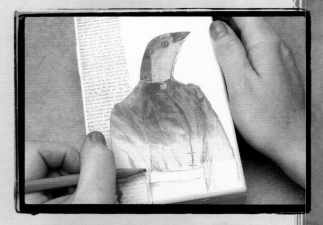

{4} Add some pencil

Redefine some areas with pencil. This can be as loose or as detailed as you like.

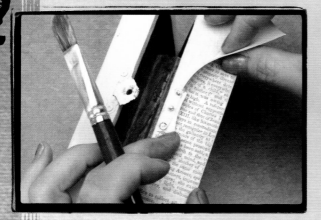

{5} Apply paper to box sides

Add some paper around the sides of the box. When you get to the area of the clasp, just tear the paper around it.

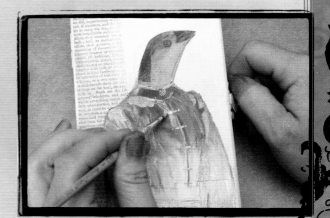

{6} Paint in details

Now go back and add some more paint for depth, including adding details like these cute little buttons. Let dry.

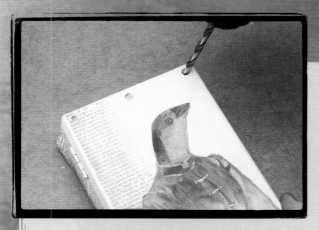

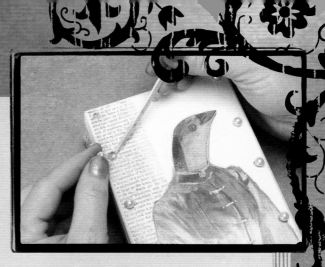

{7} Create divots

Carefully use a drill to make ³⁄₁₆" (5mm) divots for the pearls. You want to carve out a little cup, but you don't want to drill all of the way through the wood.

{8} Adhere pearls

Use epoxy to glue the pearls in the drilled divots. Let dry.

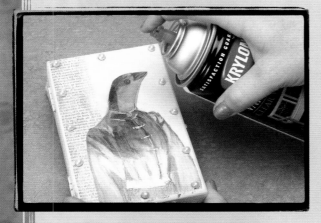

{9} Apply spray sealer

Cover the box with two coats of clear sealer, allowing drying time between coats.

{10} Add crystals and final touches

Using epoxy, adhere tiny crystals around the perimeter of the head, setting each stone by pushing it into the epoxy and letting it ooze out around it a little bit. Give the white "clean" areas a little smudge with a dry brush and gold paint before spraying the entire box with a final coat of sealer.

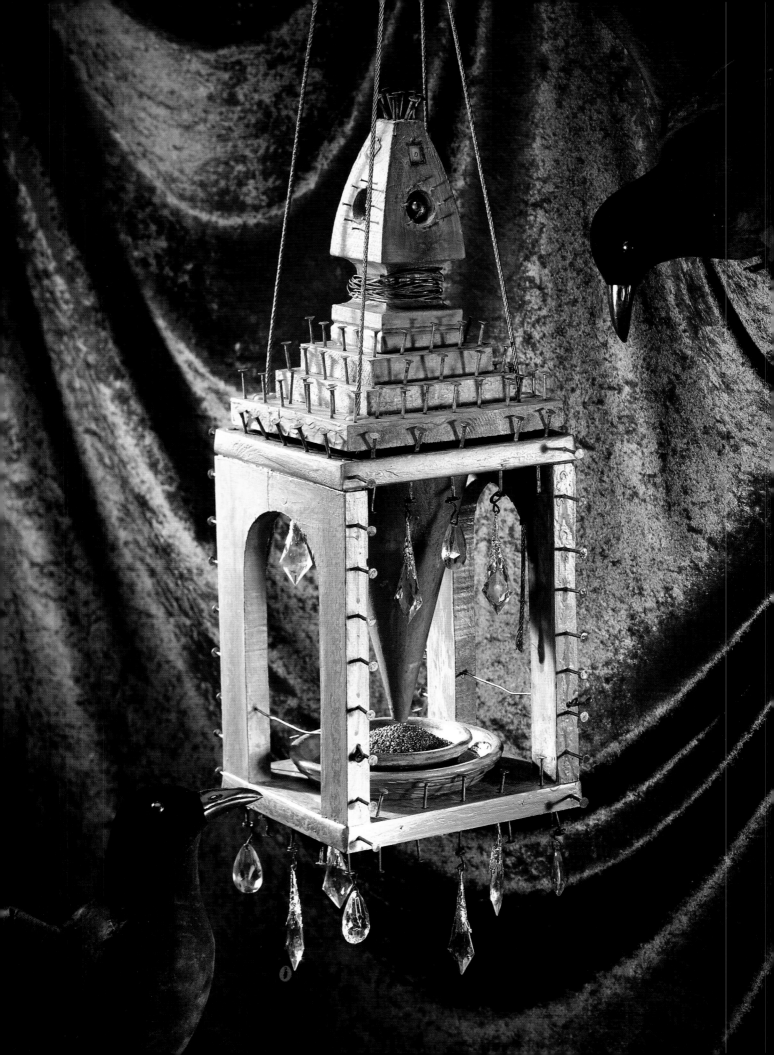

Bird Feeder

I was very lucky to grow up with my grandmother, who lived with our family. She taught me nursery rhymes and spent hours reading to me. She would tell me to look for the bird in every picture. She loved birds and thought it took a special talent to find them. We would pore though images in art books, looking and searching. In the earliest of spring before the ground had time to fully thaw, we would stand guard at the window, waiting to see the season's first robin. I think she liked keeping me busy and quiet with this little game. Even now I think of her whenever I see birds. They are such a charming reminder of her.

I take care of the little feathered people who live near me. Over the years I have had many kinds of bird feeders and birdhouses. Recently I began to make them into outdoor sculptures as a sort of tribute. This is an example of a fancy chandelier-inspired piece.

Secret Ingredients

fence post cap

square pieces of wood:
 7" (18cm), three pieces
 5" (13cm)
 4" (10cm)

drill and 5⁄16" (8mm) bit and ¾" (19mm) routing bit

rectangles of wood, 7" × 9½" (18cm × 24cm), two pieces

gold metallic paint and brush

patina solution and brush

bent needle tool

head pins

pearl

needle-nose pliers

scroll rubber stamp

gold pigment ink pad

brass nails, small and medium

hammer

metal letter charms to spell "bird"

brass floral wire

soldering screen and stand

propane torch

cemetary cone

clothesline wire

jigsaw

terra-cotta saucer

clear sealer

assorted crystals

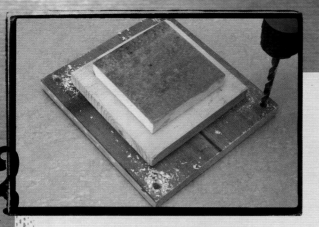

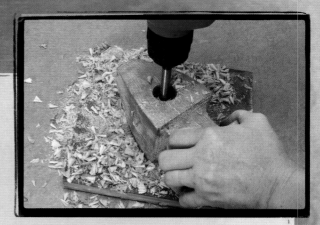

{1} Stack and drill base

Using epoxy, stack the 4" (10cm) and 5" (13cm) squares of wood onto one 7" (18cm) square. When cured, drill a 5/16" (8mm) hole into each corner.

{2} Drill holes in cap

Paint the fence cap with gold metallic paint and then add a patina. Using a ¾" (19mm) routing bit, drill a hole into each of the four sides, slightly lower than center.

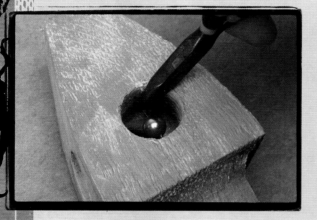

{3} Add pearls on wire

Use a bent needle tool to make a starter hole at the top of the first hole. Thread a pearl on a head pin and use pliers to push the pin up into the hole. Push it in far enough so the pearl hangs where you want it.

{4} Stamp over patina

Using a gold pigment ink pad, stamp the scroll pattern onto the bottom edge of the fence post cap.

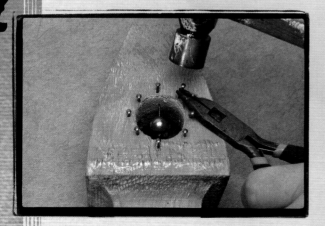

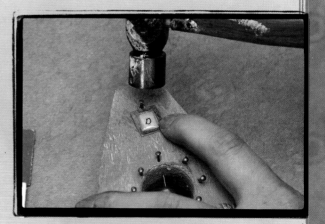

{5} Set brass nails

Use a needle tool to punch twelve holes (in a clock formation) along the perimeter of the hole. Set tiny brass nails into the holes with a hammer.

{6} Add embellishment letters

With a brass nail, hammer the letter D to the top of the fence post cap.

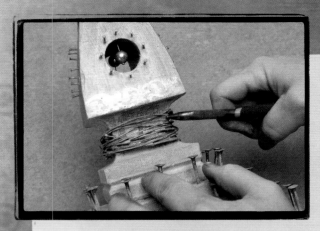

{7} Assemble wood pieces

Repeat steps 3 through 6 for the remaining three sides. Hammer several medium nails into the top of the cap and set aside. Paint and patina the stacked wood from step 1 and screw the cap to the center. Hammer medium nails along the perimeter of each square. Wrap brass wire around the base of the cap.

{8} Prepare metal cone

Burn the paint off of the cemetery cone, using a propane torch. Be sure to work in a room with adequate ventilation and, preferably, wear a mask. The cone will be used to hold the birdseed.

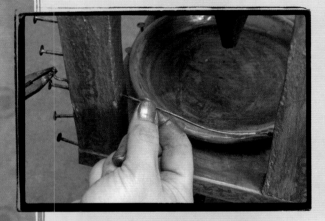

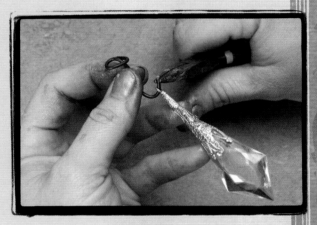

{9} Add wire perches

For the base, trace the cone onto the center of one 7" (18cm) square of wood. Cut a hole in the center, big enough to get a jigsaw blade into. Then, cut from the center to the traced line, and then around the circle to cut it out. Cut one 4" × 8½" (10cm × 22cm) arch shape out of each of the two rectangular pieces in the same way. Paint a terra-cotta saucer with ivory paint, then gold metallic paint and patina. When it's dry, seal it with clear sealer. Glue the wood for the base together as shown and paint and patina to match the cap. Set the cap piece onto the base and, using the holes in the corner as a guide, drill corresponding holes in the base. Hammer in medium nails to the outsides of the rectangles and along the top and the bottom of the bottom of the base. Drill holes through the sides of the rectangle pieces, about 2" from the bottom, then string a length of clothesline wire through the holes and across the arch opening. Curl the ends up to secure.

{10} Finish off with crystals

Using clothesline wire, attach crystals to the nails at the bottom of the base and some along the top. Fill the feeder, place the saucer in the bottom and you're good to go!

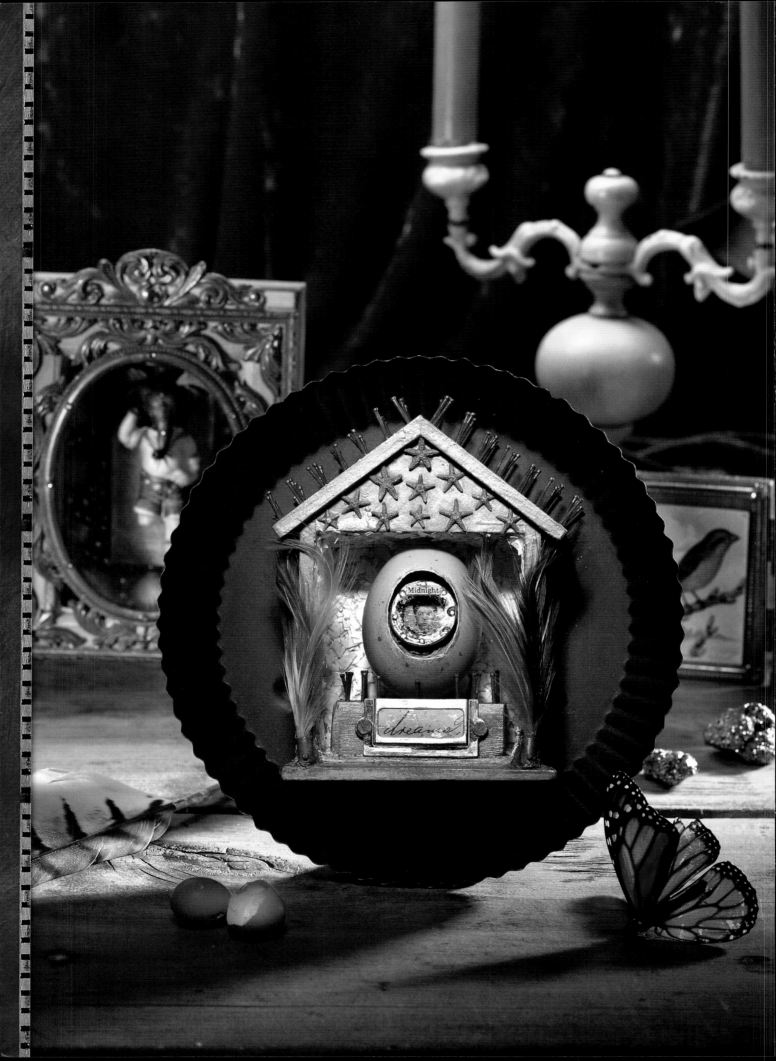

Indulge Your Spirit

PERSONAL SHRINES

The word *shrine* comes from the Latin word *scrinium*, meaning "box," and is a container of something precious or important. Most of the time when the word shrine is used it is referring to a holy or sacred object, relic or place.

There are three sections to an art shrine. The first is the box, or the housing. It is the structure encasing the objects. The second section is the subject, or the objects inside of the box. It is the careful selection of objects that come together and give a visual statement. The third and final part is the story, or the soul. This is what gives these objects relevance. It is what this collection of art stands for. The soul of your art comes from your own experiences.

When I construct my shrines, I give them the same consideration one would give to something holy. I feel there is a great connection between religious shrines and the work an artist's shrine contains. Very powerful personal meanings and feelings are contained within each creation. A great amount of time and effort goes into them, and when finished, they are powerful expressions.

As you gaze upon the creation of the shrines in this section, consider how you can apply these fundamental techniques to your own stories and your own answers to the creative puzzle.

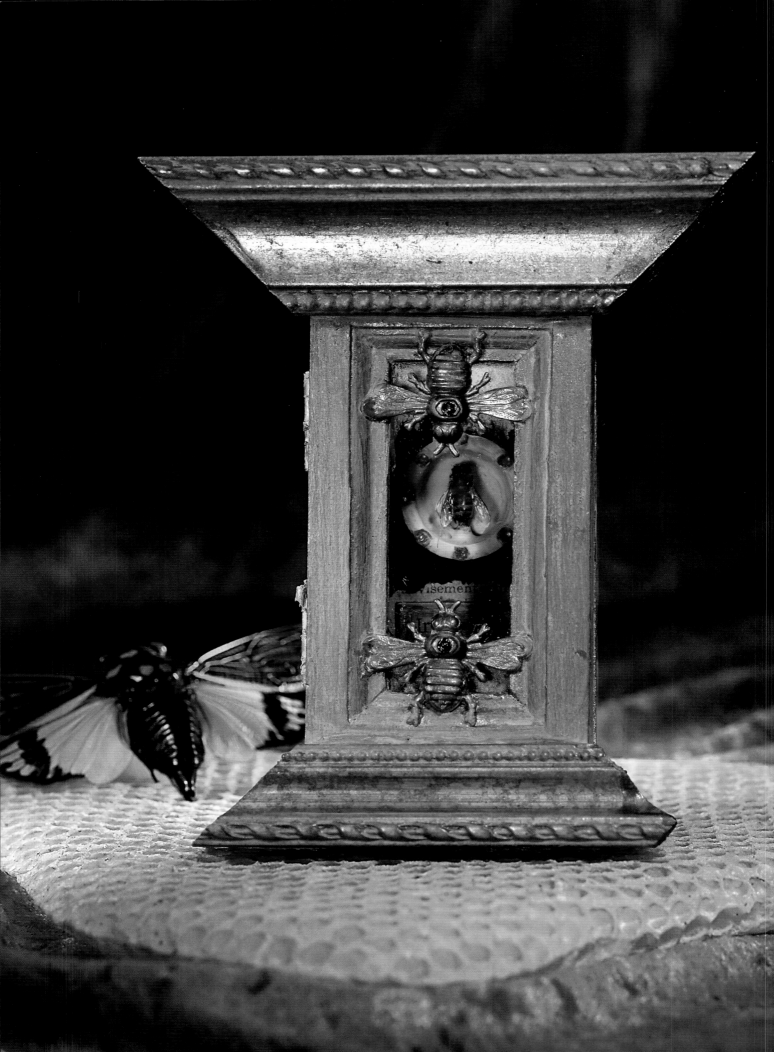

Iris
the Bee

Rachel was a patient women—a necessity for a bee charmer. It started in the early spring, when the bees arrived in pale wooden boxes. First she pried the trays from their carriers and gently dumped the bees into their new lavender home. The queen arrived last, in her tiny wooden box. She was formally named Iris. As she was carefully lowered into her hive, she greeted her loyal subjects, who all took the surname of Iris Jr.

Over the next few warm spring days, Rachel checked on their progress to see if they were settling in. Months passed, and the Iris Juniors' hard work produced a wonderful honeycomb. The cycle of life marched on: Bees were born and died, and the hive thrived. Now that winter was settling in, Iris began to hibernate, and the sounds of the low droning workers quieted down. They would sleep for now and await the warm breeze of spring that would bring their glassy wings to life.

I consider myself very fortunate to have found Rachel a few years ago. I loved reading online about her experience with Bee College and how her hard work had finally paid off for her and her family. Her words were clever and filled my days with humor and insight. Having read at my computer about her hive adventures for a year, I decided to send her an e-mail and ask her if she would save a few dearly departed Iris Juniors for me to create a shrine in honor of the hive. She was delighted to help me, and about a week or so later, six Iris Juniors arrived in the mail. They were beautiful and plump, and their bodies, furry and soft.

Rachel's storytelling reached me deeply. Inspiration and collaborations come in many usual forms. The strange and sometimes distant virtual world is never quite as far as you may think. All you need to do is make a connection like I did.

Secret Ingredients

small wood box with glass in door

drill and ¾" (19mm) router bit

metallic paint

brush

patina solution and brush

peat moss

pull cap

bee

hobby wood

battery-operated tea light

craft knife or razor blade

two-part epoxy

bent-nose pliers

bee charms

crystals

mint tin

decorative paper

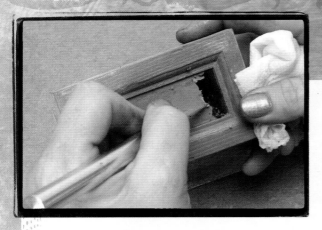

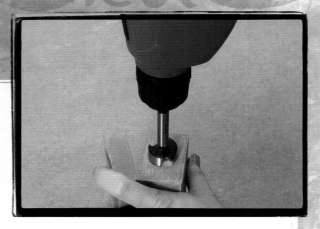

{1} Paint and patina box

Paint the entire box (inside and out) with metallic paint, and apply a patina. Don't worry about masking off the glass. Just paint right over it. When the paint and patina have dried, clean the glass by scraping it with a craft knife or razor blade.

{2} Drill hole for light

Drill a hole in the top of the box, wide enough in diameter to accommodate the tea light bulb.

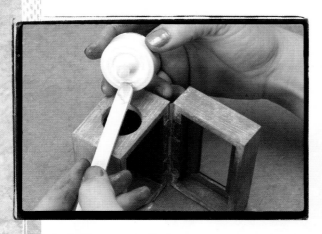

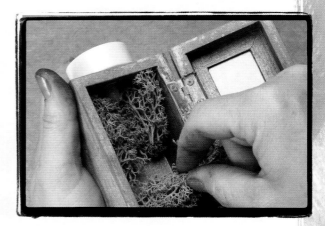

{3} Adhere tea light

Glue in the tea light using two-part epoxy.

{4} Add peat moss

Take a clump of peat moss and work it into the box.

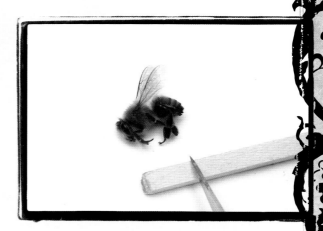

{5} Paint pull cap

To create a little environment for a creature of nature, such as my little bee, it's nice to use a little pull cap to show it off. First paint the pull cap with acrylic paint and set aside to dry.

{6} Measure wood for bee

To work with tiny, fragile specimens like my little bee, I will measure him and cut a length of ⅛" (3mm) hobby wood to the same height.

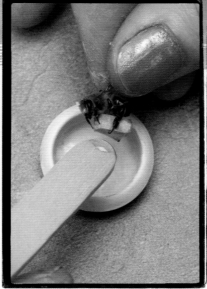

{7} Adhere bee to wood

Apply a small dab of glue to one side of the wood. Grasp the wood with bent-nose pliers. Gently hold the bee between two fingers and carefully mount the wood to its underside. Let dry.

{8} Mount bee in cup

Apply two-part epoxy to the painted pull cap and mount the bee on his little piece of wood to the cup. You may need to babysit the bee as the glue sets, because he may tip over.

{9} Add final touches

Add some little jewels to the pull cup, then mount the cup, along with some desired text into a mint tin. Add a couple of bee charms and some tiny jewel embellishments to the front.

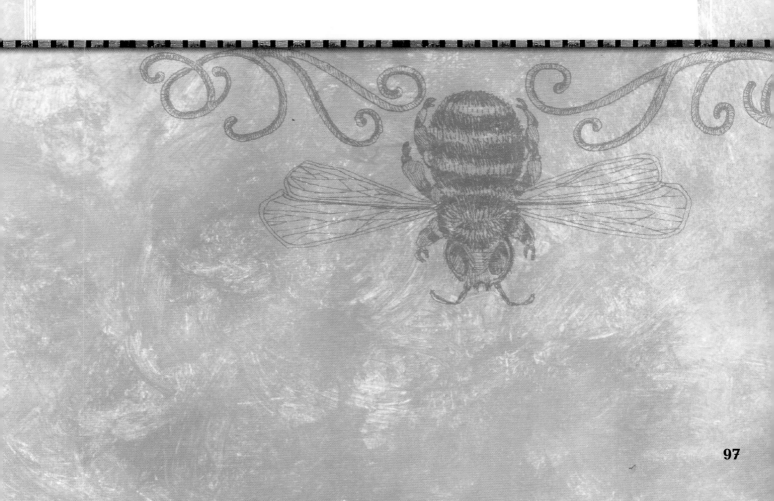

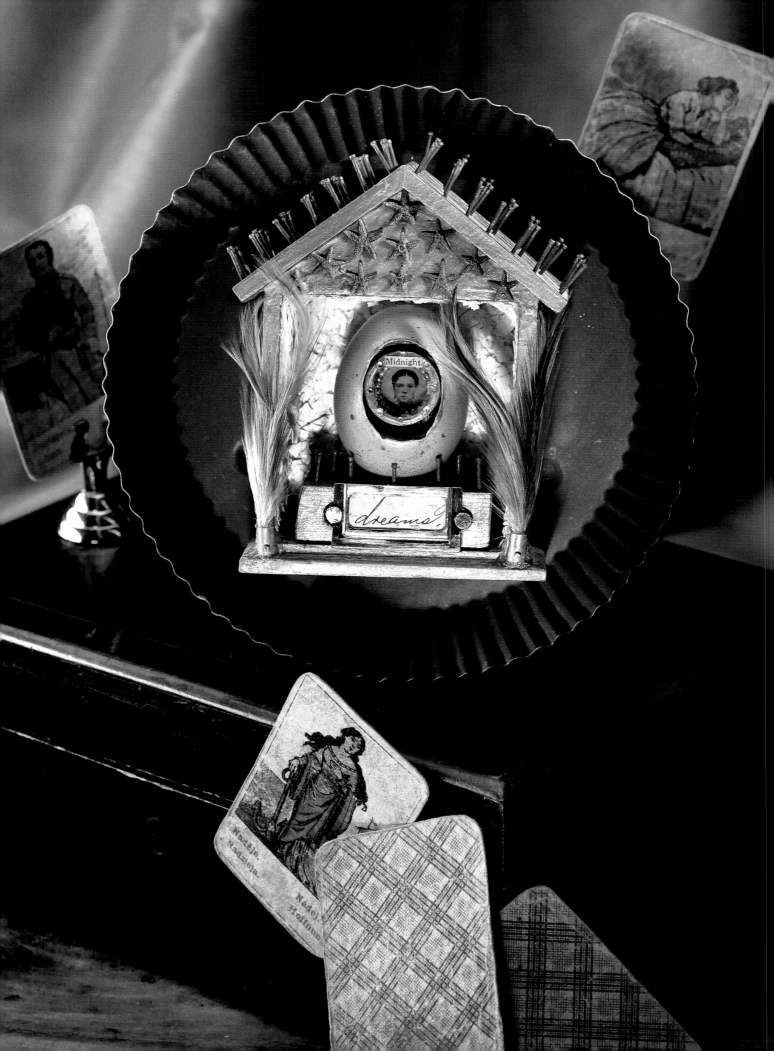

Walking on Eggshells

As grownups, we all know not to "put all of our eggs in one basket," but I remember hearing this old adage as a child on many occasions and feeling a great sense of anxiety over the meaning. In my mind, I worried that I would be risking the life of an unhatched chick if I put too many eggs in one basket, and then, worse, dropped the basket. I got part of the meaning right, but not without a flair for drama. I attribute my fascination with eggs and eggshells to this memory. Even now, I cannot break an egg without a slight hesitation. I also refuse to discard the shells because I think of them as little houses, providing protection from imminent danger.

There is more than magic that goes into altering an egg! No need to wait for the vernal equinox to explore the various possibilities of egg enchantment. Although I must confess that I do some egg balancing on the first day of spring, even though it is only a myth. Something about the unity of people everywhere, stopping for a brief moment to enjoy the sport of handling the fragile odd orbs as they try to set them upright, allows me to relish the approach of a new season even more.

Secret Ingredients

mini house cabinet	scissors
needle-nose pliers	pearls
ivory acrylic paint and brush	crystals
gold metallic paint	small piece of mica
patina solution and brush	needle tool
eggs, five or six	½" (12mm) galvanized nails
paper towels	hammer
two-part epoxy	awl (optional)
baby starfish	scrap wood
craft glue	title plate with desired text
pull cap	feathers
photo or other image	small pie plate

{1} Remove excess cabinet parts

Remove the doors and shelf from the cabinet. Pop off the shelf, using a pair of pliers.

{2} Paint cabinet

Paint the entire piece, inside and out, with ivory acrylic paint. Let dry.

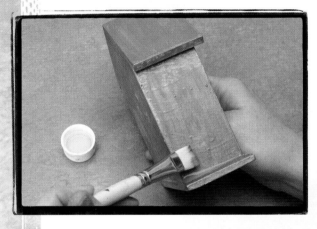

{3} Finish outside of cabinet

Paint the exterior of the cabinet with gold paint, and let dry. Next, brush on a patina.

{4} Add crushed shells

Crack the eggs and discard the whites and yolks. Crush the shells finely, and dry them between a couple layers of paper towels. Squeeze equal parts of the two-part epoxy into the interior of the cabinet, then mix it and spread it around to cover the interior walls. Pour the crushed shells into the cabinet and spread them around in the epoxy until the walls are covered in shells. Set aside to cure.

{5} Embellish the cabinet front

Add little starfish to the area under the eaves, using craft glue.

{6} Trace cap over image

To create a little image capsule for the egg's interior, trace a pull cap over a chosen image.

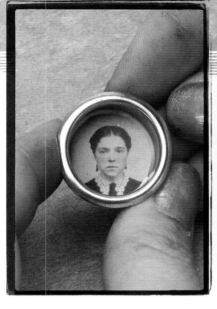

{7} Glue image in cap
Cut the image out, and glue it into the capsule.

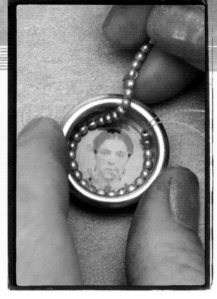

{8} Add embellishments
Adhere other embellishments, like the pearls I added here.

{9} Trace cap over mica
Place a piece of mica over the capsule, and score the perimeter with a needle tool.

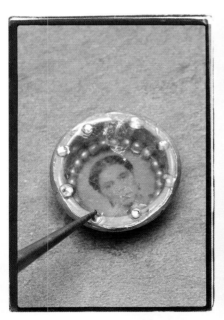

{10} Finish capsule
Using a few dots of glue, adhere the mica to the top of the cup. Add some tiny jewel embellishments around the perimeter.

{11} Alter Stars
Finally, I added a piece of text to the top of the mica. Go back and dab some gold paint onto the stars on the cabinet, and then do the same with some patina.

{12} Age nails
To instantly make galvanized nails appear rusty, drop them into a small bowl of patina for just a couple of minutes.

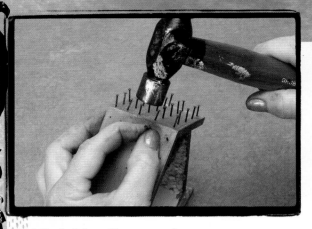

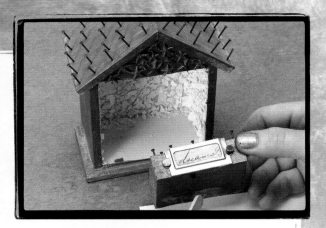

{13} Add nails to roof

Begin hammering the nails into the roof of the cabinet. I like to work in little rows. Sometimes it's easier to make little starter holes with an awl.

{14} Create egg platform

Create a platform for your egg from a scrap of wood. Paint it and add a title plate and some more little nails.

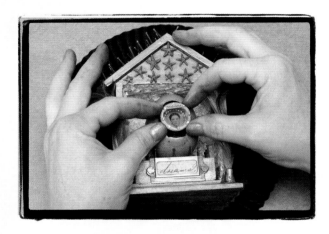

{15} Mount cabinet

To finish this piece, I added feathers on the sides, and used epoxy to glue the cabinet into a rustic pie plate. Finally, I made a nest in my egg, and added my little capsule to the center.

Egg Shrine Variation

There is no object more fitting to honor than an acorn, according to squirrel lore. This little egg shrine is the perfect thing for these three sassy squirrels. Within the delicate egg house structure is the revered golden acorn. Squirrels come far and wide to pay tribute to this sacred nut. It stands as a symbol of hope during the long winter days.

most beautiful

Carnivale

Walking on the beach in Atlantic City during the hottest part of an August day, I decided to quickly duck into the Ripley's Believe It or Not! Museum to escape for a bit. I enjoy seeing unfamiliar things being challenged by the unexplained.

I bought my ticket, and the chain-link barrier was unlocked. I entered the ambient-lit rooms and began to stroll on the dark red theater carpet, peeking into the glass displays of coveted collections. I spied shrunken heads, medieval torture devices, a Feejee Mermaid and an authentic vampire killing kit. However, nothing was as entertaining as the display of animal oddities! Beautiful conjoined creatures—cows, kittens and snakes, some with multiple legs, heads or eyes and others missing appendages—all with accompanying vintage photographs, written stories and news clippings. I truly fell in love with them. I think it has something to do with sticking up for the underdog and not wanting something so strange to not be cherished, regardless of how different it may be.

I continued on for about an hour and soaked in all the stories and theories before leaving. As I was exiting the venue, I walked by a row of fortune-telling machines, all calling to me to try my luck, see what the stars have to say and unriddle the past, but nothing turned my head faster than one of those claw machines that allows you a chance to win a prize. Upon closer inspection, I noticed the prizes were not your average childhood toys. There were stuffed shrunken heads, double-headed peacocks and, my favorite, the two-headed cow. I was speechless and blurry eyed. I must have stared at that machine as long as any exhibit I had just seen. Knowing I would have no luck at winning a prize, I snapped a few photos as my parting gift. At that moment, I knew I would find some way to play with this idea in my own work.

Secret Ingredients

wood jewelry box, glass removed

iron metallic paint and brush

hobby (bass-) wood

two-part epoxy

decorative sheet metal

drill with 1/16" (2mm) bit

small brass nails

hammer

decorative paper

watered-down craft glue

patina solution and brush

two-headed cow (see page 10)

fine copper wire

beads

picture frame molding corner sample

mica

trim molding

gold metallic paint

plastic grapes or marbles

mat board

grapevine

dental molding

crystals

pearls

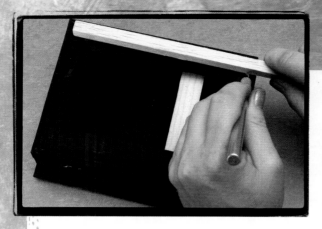

{1} Measure basswood

Begin with a standard unfinished jewelry box and paint it with metallic paint. Create additional depth on the lid of the box by adding strips of basswood. Measure and cut the wood to fit atop the lid.

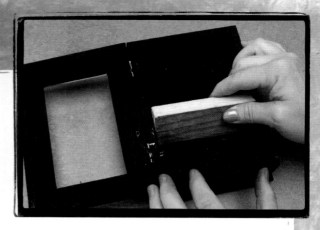

{2} Add a shelf

Cut a piece of wood to act as a shelf, and glue it into the box with two-part epoxy.

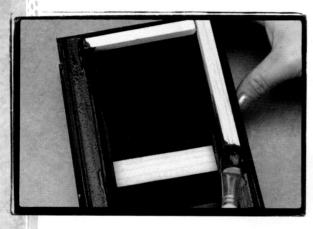

{3} Paint strips on lid

Glue basswood strips to the lid and paint them with metallic paint. Here, I'm using iron paint.

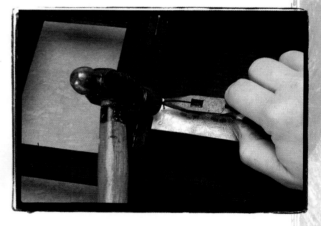

{4} Add decorative metal

Paint the shelf. Cut a piece of decorative metal to fit the edge of the shelf. Predrill or punch a couple of holes at either end, then nail the metal to the front of the shelf with a hammer and brass nails.

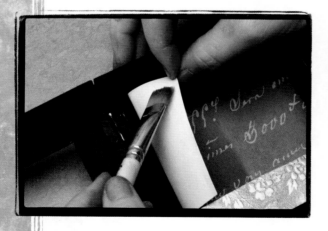

{5} Add a background

Cut a piece of decorative paper and adhere it to the back of the box, above the shelf, using craft glue.

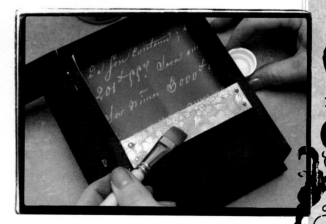

{6} Add patina to metal strip

Brush patina solution onto the decorative metal strip.

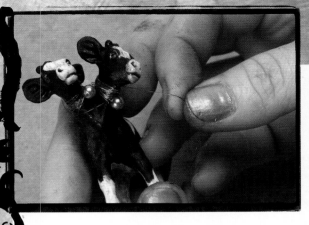

{7} Alter a toy

Create an altered animal (see page 10) and embellish with fine copper wire and a bead.

{8} Add trim

Cut two pieces of decorative trim molding, add them to the sides of the stage, and paint them with gold metallic paint and patina. Let dry.

{9} Cut a window

Cut a piece of mica for the "window" and adhere it inside of the sample, using watered-down glue.

{10} Fill roof

Fill the roof area with plastic grapes or some other interesting objects.

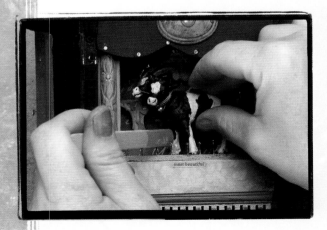

{11} Mount cow

Trim a piece of mat board backing for the roof, and adhere it with epoxy to hold in the grapes. Stuff grapevine below the stage area. Add finishing touches to complete the stage. Brush patina over the entire outside of the box. Glue the cow onto the shelf with epoxy.

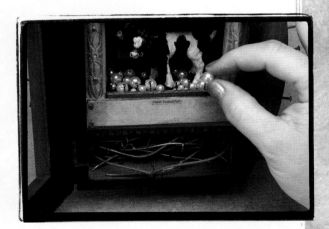

{12} Add final embellishments

Where epoxy has oozed out around the cow's feet, adhere tiny pearls for visual interest.

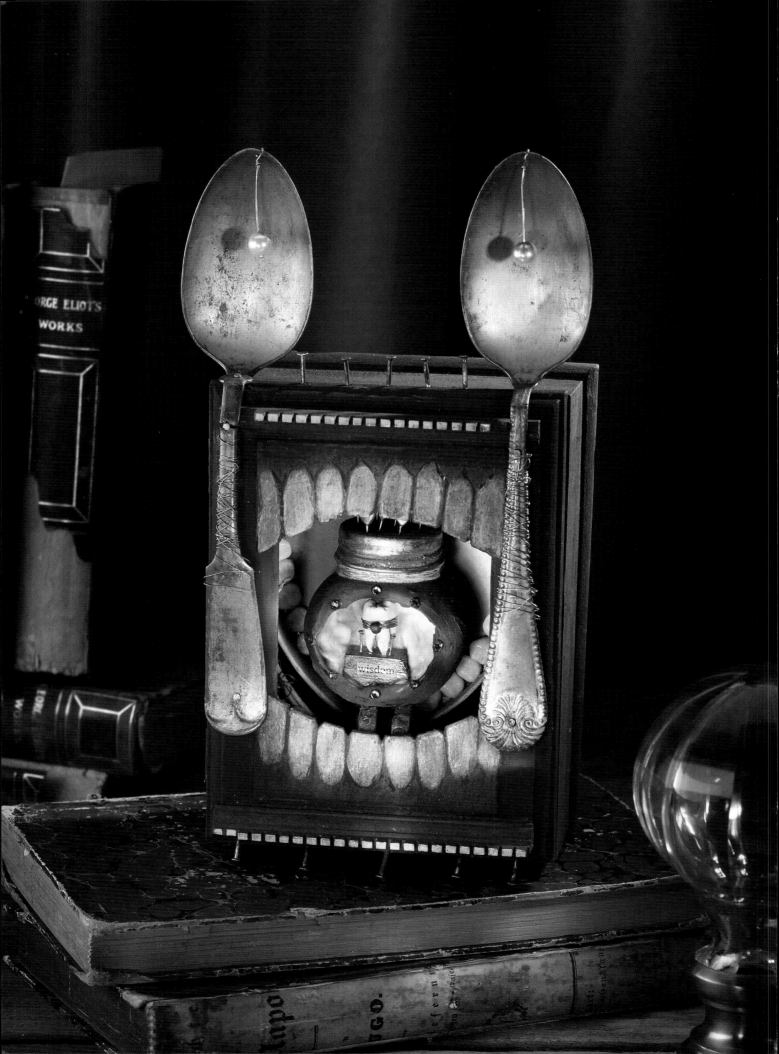

Wisdom

Wisdom teeth often arrive "later" in life, between the ages of seventeen and twenty-four. It is thought that they're called wisdom teeth because they arrive at an age where people are wiser than they were as children. When mine showed up, they made quite an impression, and removing them waged an epic battle for my dentist. I keep them safe in a little glass container on a bookcase in my dining room—a fitting place, for they are teeth after all!

I have always found teeth to be such decorative little things—like pearls. When I think back to my younger years, I remember having a lot of fun at the dentist's office. I can still see the nice lady named Rachael dressed in a pale blue pants suit. She would take me back to the room with the big chair and tiny table, where I'd put together puzzles while I waited. They had silly pictures mounted to the ceiling—like one of a cat in a tree that said "Hang in there," or one of a monkey with a huge smile—that would distract me as I had my teeth cleaned. The best part of the whole process, though, was when I was allowed to pick a toy from the treasure chest on the floor. It reminded me of a pirate ship! Inside was a huge assortment: plastic rings, whistles, mini animals, plastic puzzles, finger puppets, small boxes of crayons and an occasional toothbrush. My heart would start to beat fast just thinking about which one to choose. I knew I had one opportunity to get it right or else it would be several months before I had the chance to peek again.

Secret Ingredients

wood jewelry box, glass removed

iron metal paint

patina solution and brush

balsa wood

black acrylic paint

brush

metal heart tin

wisdom tooth

24-gauge brass wire

beads and pearls

dressmaker pins, three

two-part epoxy

craft stick

drill or Dremel tool and ⅛" bit

miniature lights strand
(battery-pack operated)

grapevine

teeth

spoons, two

small nails

hammer

dental molding

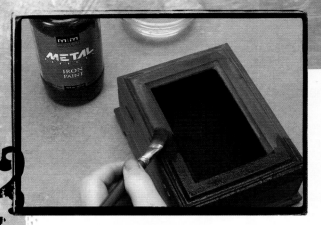

{1} Paint and patina box

Paint the wood box with metal paint and a patina. (I used iron paint, so it would rust.) If the patina has formed a bit too bright, like I felt the orange of the rust did here, you can knock the color down a bit by going over it with a watered-down coat of more paint. Let dry.

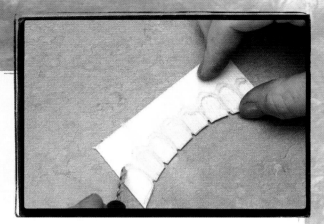

{2} Carve teeth

I wanted to add some teeth to the front of the box, so I carved out some teeth from balsa wood, using my Dremel tool. First sketch in your design with pencil, then carve along the lines until the correct depth is achieved.

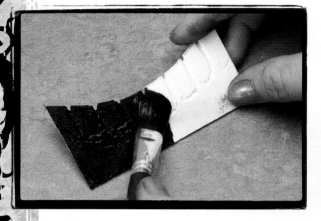

{3} Paint teeth

Give the balsa wood a coat of iron metallic paint.

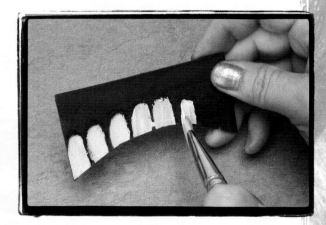

{4} Add ivory

Adding ivory paint over the teeth. Because there is a dark color down first, it will help the teeth appear less white.

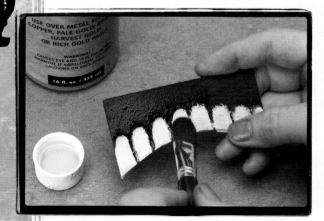

{5} Apply patina

After the second color is dry, apply a patina. Let dry.

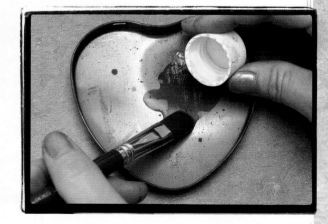

{6} Pour patina into tin

Set the balsa wood aside, and begin working on the tin that will be on the inside. Pour some patina into it and spread it around with a brush to quickly rust it. Set it aside for a moment.

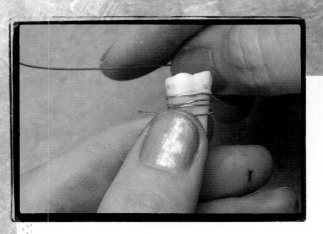

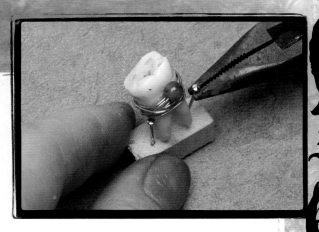

{7} Wrap tooth in wire

To "dress up" an actual wisdom tooth, first cut off about 12" (30cm) of wire and begin wrapping it around the tooth.

{8} Set tooth with pins

Add a bead and trim the excess wire. Snip three dressmaker pins in half. Push the pins into a little balsa wood "stage" for the tooth, so that it can stand up properly.

{9} Adhere balsa wood

Apply a tiny bit of epoxy to the tooth, stand it up between the pins and set it aside to cure. When it is dry, paint the wood stage and decorate it with text or any other embellishment. Glue the balsa wood pieces to the front of the box with two-part epoxy.

{10} Paint tin interior

After the patina solution inside the heart tin has dried, apply a coat of paint over the top of it. The rust will alter the paint as it works its way through it to the surface.

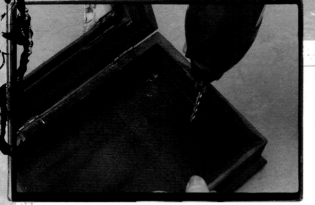

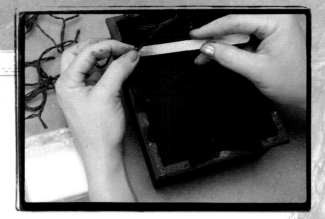

{11} Drill holes for lights

Using a Dremel tool, drill as many holes into the back of the box as there are bulbs on your strand of lights.

{12} Secure with epoxy

Begin pushing the lights through the back of the box, then dab a little epoxy around each one.

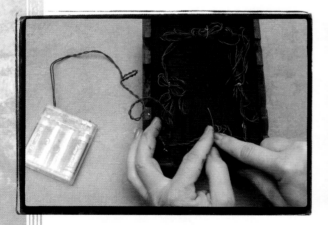

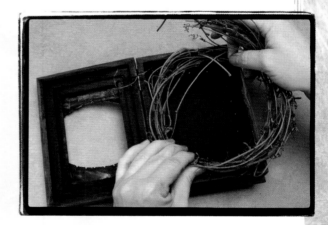

{13} Bundle wires

Using wire, bundle the wires into groups on the back.

{14} Add grapevine wreath

Use epoxy to adhere the battery pack to the center back, in the middle of the wire bundles. Next, create a small wreath out of grapevine and push it in into the box.

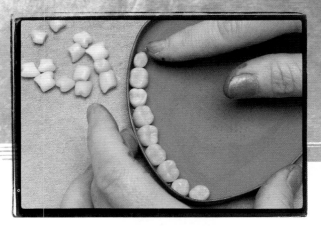

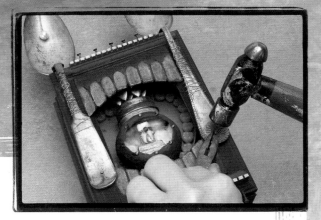

{15} Add embellishments to tin

Glue individual teeth around the perimeter of the little heart tin.

{16} Add finishing touches

Set the wisdom tooth in a broken bottle (see page 14). Embellish the bottle with a crown and jewels. Add some dental molding on the front of the box and attach the bottle to the shrine with epoxy. Set aside to cure. Drill holes into a couple of spoons and wrap them with wire. Dangle some pearls from wire and nail the spoons to the front of the box.

Elephant Boy, Lost No More

I had no idea that Ganesha, the Hindu god of success, would pay me a visit when I started creating this piece. Ganesha is considered the master of intellect and wisdom and is commonly depicted as a seated man with the head of an elephant. Fused together, this tiny ceramic broken toy sailor and the head of a plastic elephant make a playful icon of good fortune and prosperity.

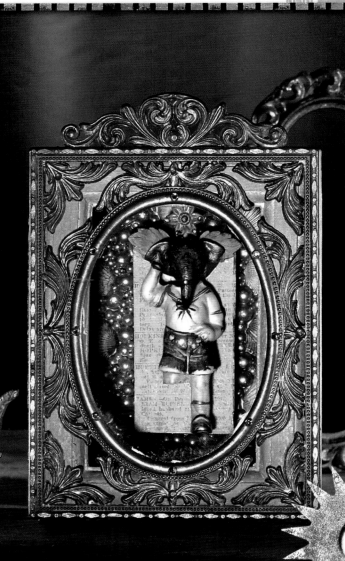

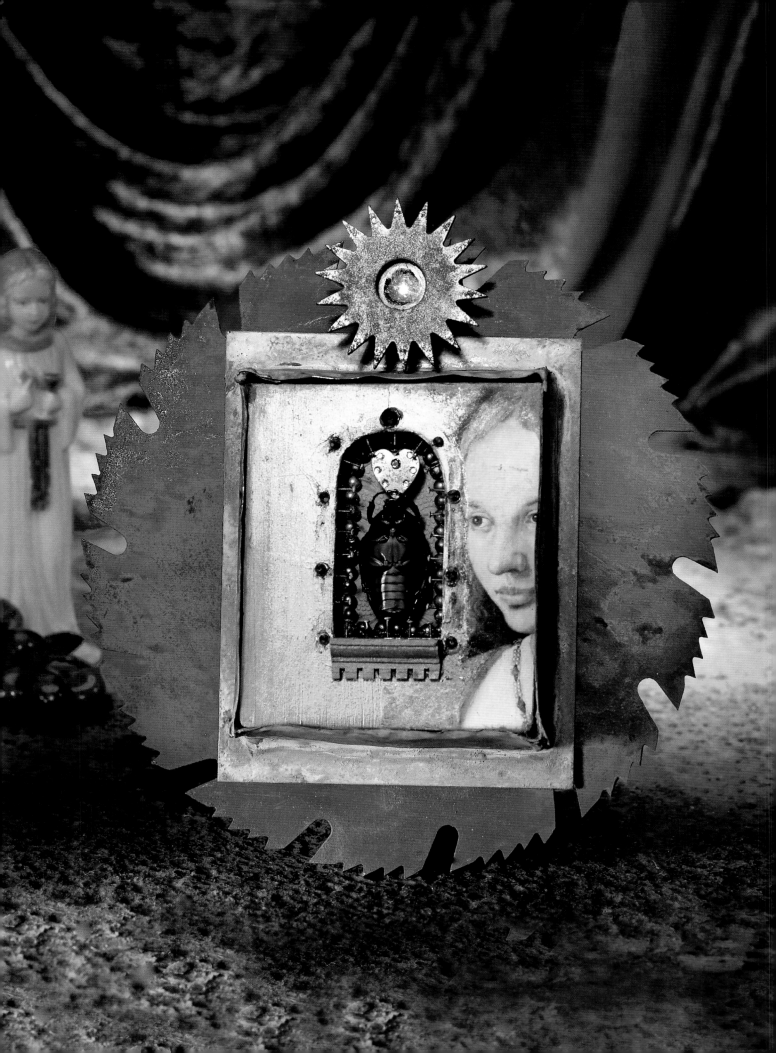

Rhomborrhina and Me

It is said that the ancient Egyptians thought of the sacred scarab beetle as a holy creature. The scarab represented the sun god Ra because of its warm, bright, metallic colors. They believed the rising and setting of the daily sun corresponded with the beetles rolling a ball of dung along the ground.

Rhomborrhina is part of a genus of large scarab beetles. My personal little beauty came to me from Indonesia. When I opened the little container I was immediately smitten with him. His delicate legs, his tiny head and the overwhelming metallic color of his exoskeleton were quite a sight to see. I picked him up carefully and turned him over. His colors were equally brilliant on both sides. I was amazed he had such a presence and weight for such a small creature. I stared at him for a long time and thought to myself that I would never see anything more perfect in detail and color as long as I live. (I do have a soft spot in my heart for insects.) I decided that this regal little god should be given a special home. I just had to find an inspiration or a vision first.

This beetle's colors made me instantly think of European Renaissance and Baroque art. Decadent gold frames thick with age were sometimes larger than the paintings themselves. I thought that if this little insect of mine were still alive, it could be released into a museum full of this lovely art. It could crawl up the wall and make a happy home of a painting and no one would notice! I decided to build a tiny regal home for my friend with the impression and awareness of a rich Renaissance painting. A little golden shrine built for the Sun God.

Secret Ingredients

- 20-gauge brass or other base metal sheet
- two-part epoxy
- craft stick
- craft knife
- mini squeeze clamps
- brick or other large weighty object
- sandpaper
- patina solution and brush
- scrap of wood
- drill and ¾" (19mm) router bit
- jigsaw
- color-copied image
- découpage medium
- gold metallic paint and brush
- textured paper
- white glue
- beetle
- hobby (bass-) wood
- assorted sizes of pearls
- dressmaker pins
- old saw blade
- jewels
- metal gear

{1} Join first two sides

Cut a metal base to 4" × 5" (10cm × 13cm). Cut standard 1" (3cm) strips into two 3¼" (8cm) pieces and two 4" (16cm) pieces. Mix up some two-part epoxy and create a four-sided frame with the strips, as shown here. Begin by joining one long side to each of the two short sides.

{2} Adhere sides to base

Next, join the two L-shapes together to form a frame. Adhere that to the large base piece by setting it in place, then spreading epoxy around on the inside, where the sides meet the base.

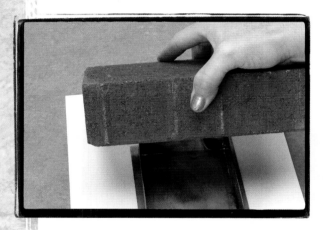

{3} Apply weight

Set a weight (like a brick or a stack of books) atop the shrine to weigh it as it cures.

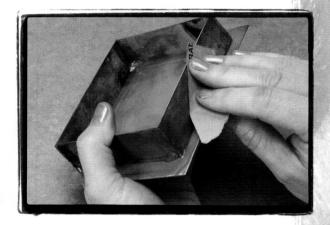

{4} Sand away glue

Remove excess glue with a craft knife or sandpaper.

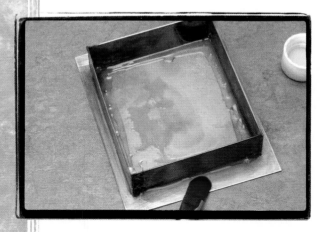

{5} Apply patina

Add a patina to the box.

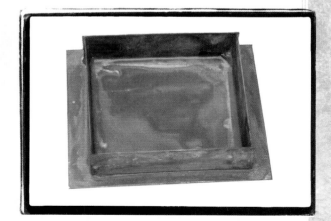

{6} Let patina develop

This box came out lovely with its dark green shades.

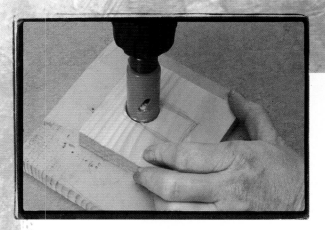

{7} Create arch

Cut a scrap of wood to fit the metal shrine box.
Using a pencil, sketch an arch shape onto the wood.
Use a jigsaw to cut the straight portions and a router
bit to remove the arched portion at the top.

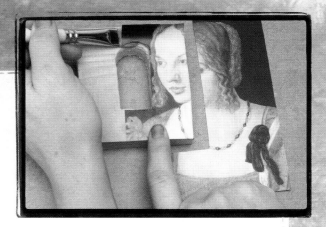

{8} Apply image

Cut the rest of the shape out with a jigsaw or
hacksaw. Clean up the edges with sandpaper,
then adhere your chosen image to the wood with
découpage medium.

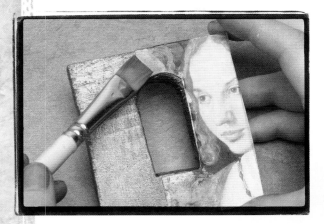

{9} Add gold paint

Paint the remainder of the wood with gold metal-
lic paint. Where the background of the image ends
and the wood begins, gently blend the paint over the
paper to mesh them together.

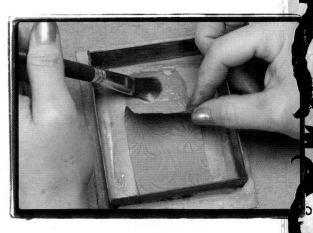

{10} Adhere decorative paper

For the background that will be visible through
the arch shape in the wood, adhere a piece of
textured paper to the back of the metal box,
using white glue.

{11} Mount beetle on wood

Use epoxy to adhere the wood into the metal box. Trim
a small piece of basswood to the length of the beetle. Mix
some two-part epoxy and apply a small dab to one side of
the basswood. Gently stick the back of the beetle into the
epoxy. Watch the beetle for a few minutes as the glue is
setting to make sure he doesn't slip off the wood.

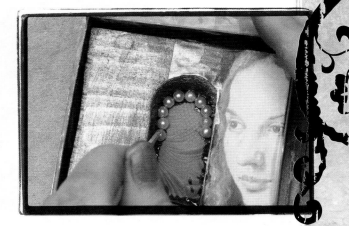

{12} Add pearls

Along the perimeter of the back of the arch shape,
use epoxy to adhere assorted sizes of pearls.

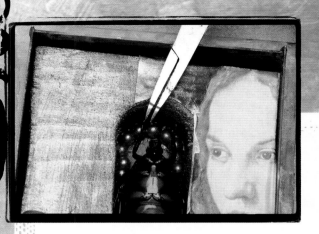 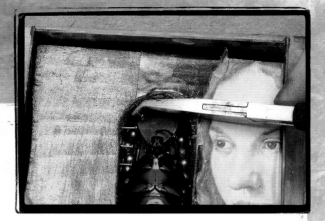

{13} Set in beetle

Nestle the beetle in the center of his ring of pearls, using epoxy.

{14} Push in pins

Push pins around the sides of the archway.

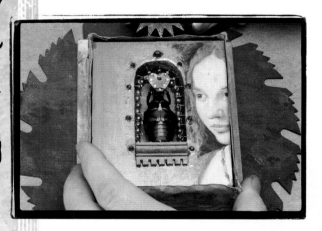

{15} Top with final element

Using epoxy, adhere the metal box to the center of the saw blade and add any additional embellishments, such as jewels, to the piece. Finally, adhere a crowning touch, such as a gear or other sun-shaped object to the shrine.

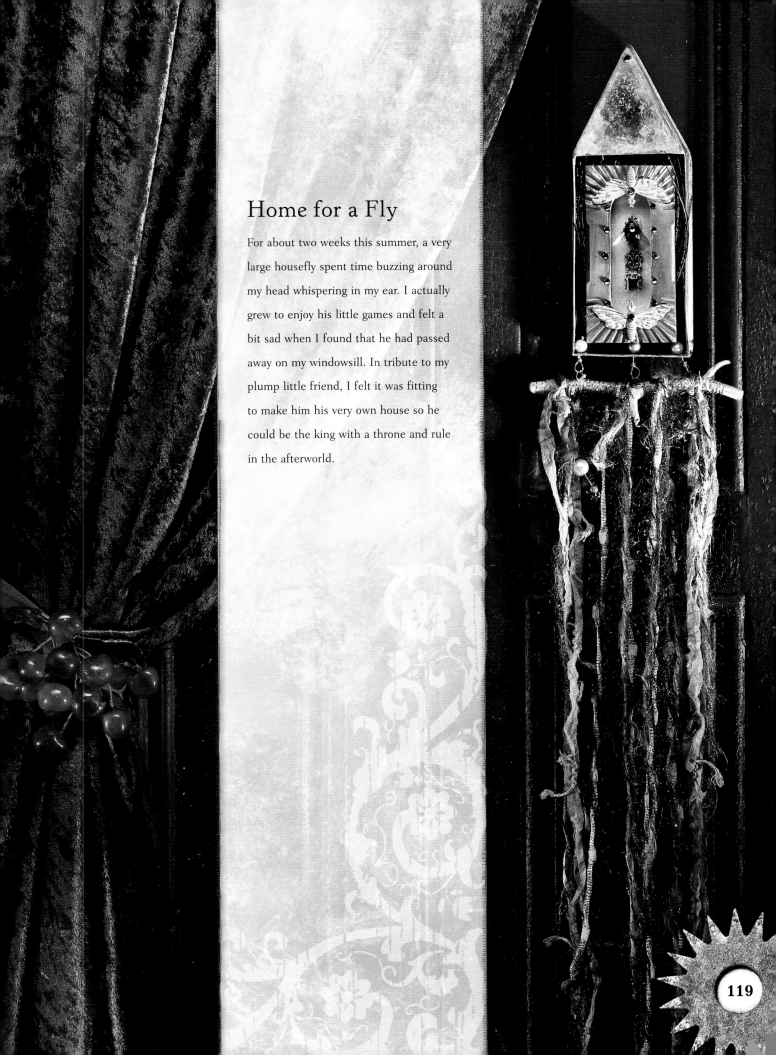

Home for a Fly

For about two weeks this summer, a very large housefly spent time buzzing around my head whispering in my ear. I actually grew to enjoy his little games and felt a bit sad when I found that he had passed away on my windowsill. In tribute to my plump little friend, I felt it was fitting to make him his very own house so he could be the king with a throne and rule in the afterworld.

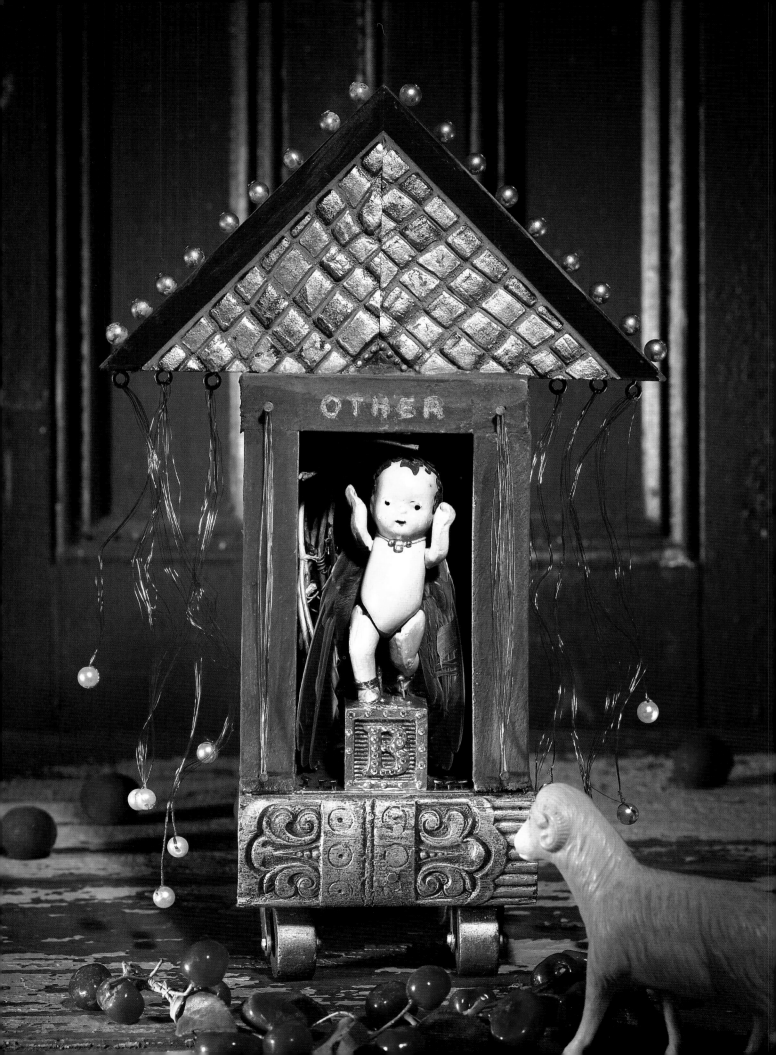

Saint of Wayward Shrines

Unusual objects have a strange way of finding me. When I was in college, I had a small studio space. Outside of my studio door were a bunch of old filing cabinets that were perfect for me to set my things on to work. When I would visit my studio, I would find little offerings left for me. Sometimes it was bike parts or old shoes, and other times it was wonderfully odd cicadas or small bones. I loved these anonymous gifts! After graduating college, these odd gifts seemed to continue. I would get lovely strange things in the mail from time to time. Other times, I would be out and about and would have someone give me something just for being in the right place.

Once, I was given a pair of bird wings from a dear friend. She had come across them one day and took the time to save them and send them to me. I think it takes a dear friend to give such gifts; it's not the type of thing you would normally get as a party gift. I held onto these fragile wings for some time and waited for the right moment to use them. Whenever I began a new piece with the intention of using them, it turned out not to be the right time. They were either too large or too small or just not right for the piece. So I'd wait until I made yet another shine, but it just wasn't working out.

Then one day I made a little house. It was empty and somewhat small. It had wheels at the bottom and a pointy top for a pitched roof. It was completely humble. I looked inside and saw nothing and could not imagine how to fill it. As it was sitting on my workbench, I looked past the house and saw a little broken doll staring at me. He spoke volumes without saying a word. I picked him up and gazed at him. He was tiny but had a strong victorious spirit in his damaged state. At that moment, I knew he was the one to wear those little bird wings! It was a brilliant match. He fit nicely and became my little Saint of Shrines. This was his perfect home.

Secret Ingredients

wood

two-part epoxy

nails

hammer

picture frame molding samples
(outdated samples found at picture
framing shops) or scrap wood

black or ivory acrylic paint

brush

vinyl letters

burnisher or bone folder

iron metal surfacer paint

rust patina solution

vintage ceramic doll

bird wings

small vintage wheels

vintage children's toy block

fine-gauge copper wire

beads, pearls

That's Odd!

I prefer to use epoxy instead of wood glue for gluing wood, because I tend to do a lot of pounding on the shrines as I'm altering and adding things to them, and the epoxy holds up better under all of this stress.

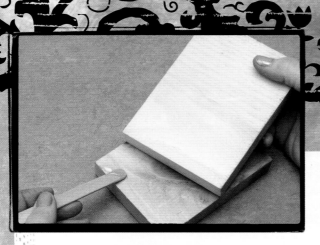

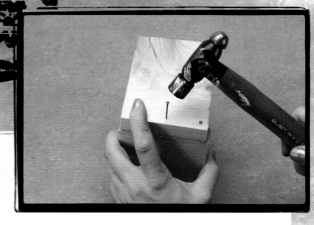

{1} Join first two pieces

Begin with four pieces of wood that are all the same width. For a rectangle, I chose two long pieces of equal lenth and two shorter piece of equal length. Glue each short piece to one long piece, using two-part epoxy.

{2} Nail to secure

Join the second two pieces in the same way, then connect the two Ls together to form one rectangle. When the epoxy has cured, reinforce the joins with nails and a hammer.

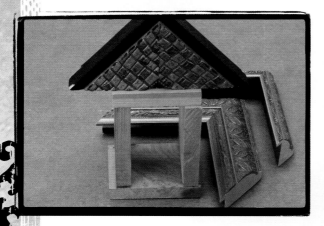

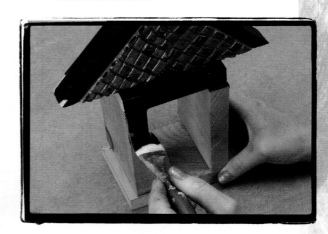

{3} Decide on roof

Many things can serve as a roof for a shrine. Visit a local frame shop and ask them for their discontinued molding samples, then try different ones to see which works best. Or, use additional scrap pieces of wood to make a roof. Glue the roof or shrine top onto the base with epoxy.

{4} Apply metallic paint

Decide if the shrine is to be more rusted or have a lovely patina. If using a rust solution, paint a basecoat of black paint over the wood. If using a greenish patina, paint a basecoat of ivory over the wood.

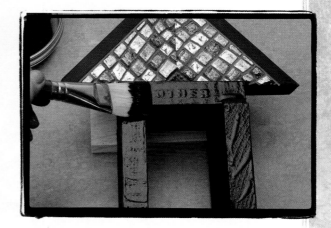

{5} Apply letters for resist

After the basecoat is dry, you can either immediately add a coat of metal paint, or you can first lay down some stickers or vinyl letters, which will be used to resist the patina later. Here, I added the letters to spell "other." Burnish the letters well with a burnisher or bone folder.

{6} Add metal paint

If you've added vinyl letters or stickers, now you can paint the entire box with metal paint. Here I used iron paint (Modern Masters).

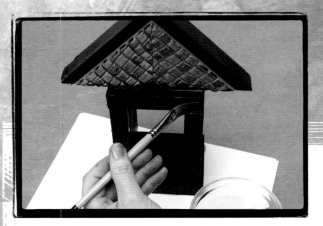

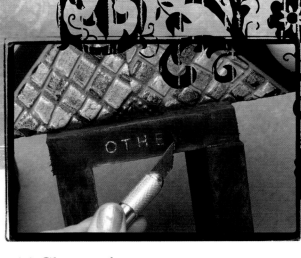

{7} Add patina

After the metal paint has dried, brush over the entire box with green patina.

{8} Clean up letters

After the rust has come through and it's dry, you may want to add more solution to fill in the areas that aren't as rusty yet. When all coats are dry, remove the vinyl letters or stickers (if you added any in step 5), gently using a craft knife. You can clean up the letters, if need be, with the craft knife.

Your shrine is now ready for a special someone to inhabit it. Here I placed this lovely little doll inside and gave him a fine set of wings. Fine-gauge copper wire and pearls add a sense of magic, and a set of wheels means this little saint can quickly get to wherever he needs to be to spread inspiration.

Sleepy Orange

I have a passion for collecting insects—particularly butterflies. I am inspired by their extraordinary colors and textures and often look through my collection when I am in need of some visual inspiration. Wings are perfect for this teeny china doll with the coy smile. It must be her southern charm and her witty expression that helped me decide to make her the queen of hearts.

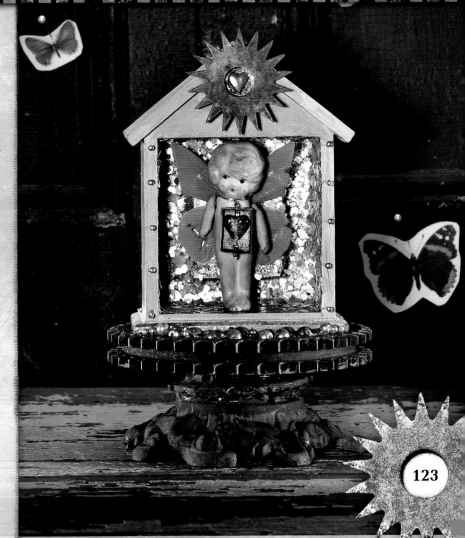

Trade Secrets (Resources)

Beads and finished jewelry
Wynwoods Gallery and Bead Studio
www.wynwoods.com

Collage supplies
ARTchix Studio
www.artchixstudio.com

Jewelry supplies
Rio Grande
www.riogrande.com

Jewelry supplies
Terra Firma Enterprises
www.tfeinc.biz

Metallic paint
Mayco Colors
www.maycocolors.com

Metals and metal tools
Metalliferous
www.metalliferous.com

Mold-making silicones/casting resins
Alumilite
www.alumilite.com

Modeler's putty
The War Store
www.thewarstore.net

Notebooks and sketchbooks
Moleskines.com
www.moleskines.com

Patina solutions and metallic finishes
JAX Chemical Company
www.jaxchemical.com

Patina solutions and metallic finishes
Modern Masters
www.modernmastersinc.com

Patina Solutions and metallic finishes
Modern Options
www.modernoptions.com

Popular culture fun
Archie McPhee
www.mcphee.com

Envitotex Lite (resin)
Envitonmental Technology Inc.
www.eti-usa.com

Stamps and ink
The Queen's Ink
www.queensink.com

Taxidermy supplies
Van Dyke's Taxidermy
www.vandykestaxidermy.com

Tools
Harbor Freight
www.harborfreight.com

Toy animals
Safari Ltd.
www.safariltd.com

Unique natural history collectibles
The Evolution Store
www.evolutionnyc.com

Whatever else you'd ever want or need
eBay
www.ebay.com

Inspiring Artists

Nina Bagley
www.ninabagley.com

Christopher Bales
www.christopherbales.com

Keith Lo Bue
www.lobue-art.com

Ray Caesar
www.raycaesar.com

Colette Calascione
www.calascione.com

Michael deMeng
www.michaeldemeng.com

Gus Fink
www.gusfink.com

Jared Joslin
www.jaredjoslin.com

Jessica Joslin
www.jessicajoslin.com

Kerry Kate
www.octobereffigies.com

Lola
www.lolastrangeart.com

Travis A. Louie
www.travislouie.artroof.com

Angie Mason
www.angiemason.com

Nicole McConville
www.sigilation.com

Elizabeth McGrath
www.elizabethmcgrath.com

Dave McKean
www.mckean-art.co.uk

Scott Musgrove
www.scottmusgrove.com

Kathie Olivas
www.miserychildren.com

Jennifer Parrish
www.parrishrelics.com

Lynne Perrella
www.lkperrella.com

Scott Radke
www.scottradke.com

Beth Robinson
www.strangedolls.wordpress.com

Mark Ryden
www.markryden.com

Jason Sloan
www.jasonsloan.com

James Michael Starr
www.jamesmichaelstarr.com

Kevin Titzer
www.kevintitzer.com

Jonathan Weiner
www.viner.biz

John and Lynn Whipple
www.whippleart.com

❀ Index ❀

✸ Who is Jane? ✸

Mercury in Retrograde—A Method to My Madness

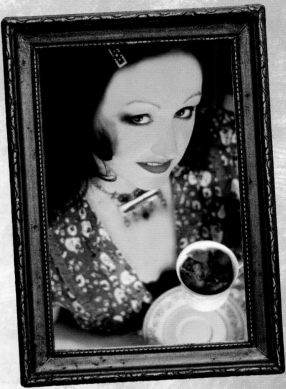

"You are quite the walking contradiction," he said. I immediately thanked him with a warm, thin smile and shook his hand with great strength and gratitude. Then, I threw my plate of food away and walked out. I didn't want to disappoint his expectations. I was quite young when I heard these words used to describe my art. I didn't know it then, but it was one of the best compliments I had ever gotten. Some of the best words are the most bitter when you are young.

I filter through life at a perfectly happy pace. I have been told I have great patience with people, when most have given into frustration. I try to look for the bright side of dark situations, I tolerate the awkward, and I bend in the breeze without breaking. I have chosen the title of optimist and wear it proudly no matter how heavy it can be.

Although . . . I must confess that on the right occasion, I love a good, sad song: something so strong and emotional, with a delicious theme of heartbreak, or the unexpected passing of life. If it is set to a slow churning melody, or has a happy dissonance, I am completely smitten. I love the sad things in life as much as I love life itself. I respect its complement. It has as strong a pull on the heart as pure joy has.

I try to find a clever balance between these two emotions in my work. One emotion, "joy," only works because the other one, "sorrow," is present. Without these two working together, my work fails and is forever lost in a defined classification. I feel that if I am going to create a successful piece of work, I need to find different ways to define these emotions in subtle ways. Take, for instance, "joy"—it can be characterized by my choice of colors. Deep and bright crimson accented against an equally suggestive cool aqua tone creates an aggressive state of excitement and passion. Juxtapose it with a broken glass heart bottle and all of its connotations, and instantly the "joy" is gone. I do not think I have all of the perfect answers. I am always looking for new ways to do old things, or sometimes I am just searching for *my* way. I keep reading, experimenting, tinkering and laboring like a spider making a web. I am in love with the process as much as I am with the results. To me, *that* is when I'm doing the real living.

To see more of Jane's work, you can visit her Web site:

www.wynnstudio.com

127

Indulge your creative curiosity with these North Light Books.

Pretty Little Things
Sally Jean Alexander

Learn how to use vintage ephemera, found objects, old photographs and scavenged text to make playful pretty little things, including charms, vials, miniature shrines, reliquary boxes and much more. Sally Jean's easy and accessible soldering techniques for capturing collages within glass make for whimsical projects, and her all-around magical style makes this charming book a crafter's fairy tale.

ISBN-10: 1-58180-842-9
ISBN-13: 978-1-58180-842-1
paperback
128 pages
Z0012

Kaleidoscope
Suzanne Simanaitis

Get up and make some art! *Kaleidoscope* delivers your creative muse directly to your workspace. Featuring interactive and energizing creativity prompts ranging from inspiring stories to personality tests, doodle exercises, purses in duct tape and a cut-and-fold shrine, this is one-stop shopping for getting your creative juices flowing. The book showcases eye candy artwork and projects with instruction from some of the hottest collage, mixed-media and altered artists on the Zine scene today.

ISBN-10: 1-58180-879-8
ISBN-13: 978-1-58180-879-7
paperback
144 pages
Z0346

Wide Open
Randi Feuerhelm-Watts

Open yourself up to a whole new way of looking at yourself, your world and your art journaling. The *Wide Open* book and deck set is all about challenging yourself to take your art to the next level. The set includes 50 idea cards featuring mixed media artist Randi Feuerhelm-Watts's art on one side and thought-provoking instruction on the other, plus a journal for recording your ideas and artwork.

ISBN-10: 1-58180-911-5
ISBN-13: 978-1-58180-911-4
50-card deck in a box with accompanying 64-page journal
Z0653

Secrets of Rusty Things
Michael deMeng

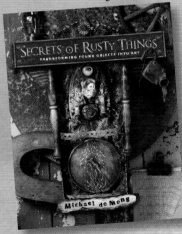

Learn how to transform common, discarded materials into shrine-like assemblages infused with personal meaning and inspired by ancient myths and metaphors. As you follow along with author Michael deMeng, you'll see the magic in creating art using unlikely objects such as rusty doorpulls, old sardine tins and other quirky odds and ends. This book provides inspiring assemblage techniques, shows you where to look for great junk and provides a jump start for you to make your own unique pieces.

ISBN-10 1-58180-928-X
ISBN-13 978-1-58180-928-2
paperback
128 pages
Z0556

These books and other fine North Light titles are available from your local art and craft retailer, bookstore or online supplier.